Sketching
with
JEAN PARRY-WILLIAMS

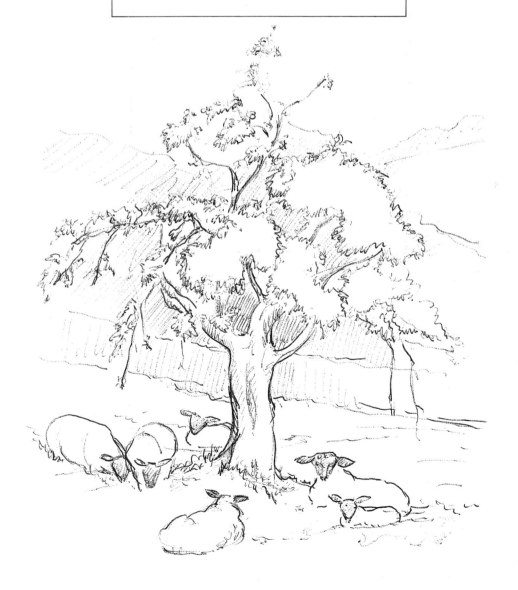

First published in 1988
by William Collins Sons & Co., Ltd
London · Glasgow · Sydney
Auckland · Toronto · Johannesburg

Reprinted 1989

**British Library Cataloguing in
Publication Data**
Parry-Williams, Jean
Artist's sketchbook
1. Drawing
I. Title
741.2 NC710

ISBN 0–00–412328–X

Art Editor: Caroline Hill
Designer: Tim Higgins
Filmset by J & L Composition Ltd,
Filey, North Yorkshire
Originated, printed and bound
in Hong Kong by
Wing King Tong Co. Ltd

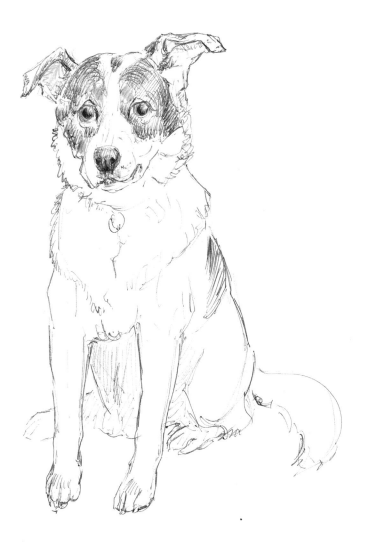

PORTRAIT OF AN ARTIST

Jean Parry-Williams was brought up in the country on the Cheshire-Derbyshire borders and lived in a home which was always full of animals. She studied at the Royal Salford College of Art and then spent a year in Vienna at a well-known studio and was thrilled to have the chance of studying from the portfolios of original drawings by Albrecht Dürer. Here, too, she was lucky enough to attend and sketch the rehearsals of the famous Lipizzaner horses in the Spanish Riding School.

Jean has exhibited in various provincial and London open exhibitions, including the Royal Academy, and has had her own shows of mixed-media paintings held in London. These shows also toured the provinces. However, animal portraiture began to take up more and more of her time as commissions started to come her way.

Jean writes and illustrates articles for the *Leisure Painter* and regularly gives lectures and demonstrations for Daler-Rowney. In addition, she works as a freelance lecturer for various Colleges of Further Education and at clubs, and is the tutor for the Pitman Pastel Correspondence Course. She also runs small painting classes from her own studio in Gloucestershire.

Although Jean Parry-Williams specialises in animal portraiture and has appeared on television demonstrating this, her favourite subject, she also enjoys painting landscapes, seascapes, still life and portraits in oil, watercolour and pastel. Her paintings are in many private collections throughout the United Kingdom and as far afield as Denmark, Pakistan and the USA.

3

Sketching is a part of my daily life. I seldom go out of the house without taking a small sketchbook with me in which to capture, perhaps only in a few lines, things which interest or inspire me. The sketches are sometimes very 'sketchy' indeed, and are often quite private statements, generally unfinished, but enough to remind me of the subject, or particular incident, that I sketched. A sketchbook is also a place in which to try out ideas, only some of which will be taken through to completion. That is why it is so fascinating to look at other artists' sketchbooks because in them you can see how ideas have been developed.

My very first attempts at sketching were when I was about five years old. I had seen some sporting prints and, thus influenced, I had painstakingly sketched a hunting frieze all round the newly-painted white bathroom walls of my parents' house! I drew huntsmen and horses leaping over fences, and hounds chasing the hapless fox. I can still remember my satisfaction when it was finished, and my dismay when it was received with cries of horror by the 'grown-ups'. But my father, always my champion, just told me in a kindly manner that one didn't draw on walls, especially newly-painted ones, but promised to give me a big sketchbook and some pencils, so that I could draw to my heart's content – and I have been doing so ever since!

Of all the artists who have influenced me, I think the most important were Rembrandt, Albrecht Dürer, George Stubbs, and above all, Charles Tunnicliffe, whose superb woodcuts of farm animals inspired me from an early age, especially since he was a local artist in Cheshire where I grew up.

I find that sketchbooks are an essential tool for my work as an animal artist and I recommend that anyone interested in sketching animals should try to use a sketchbook as much as possible – in fact, it really is a good discipline to try to sketch something every day.

Sketchbooks are a vital piece of luggage when going on holiday, too. I find it quite extraordinary how a sketchbook can become a passport to so many places when one is travelling. People are always fascinated to see someone sitting sketching and they will often stop to talk, or offer to guide you to places of interest off the normal tourist track. At times I have been lucky enough to discover little squares and fountains, or unusual artefacts, through local inhabitants showing me things of interest that they thought I'd like to sketch. I remember the owners of the quaint little horse-drawn carriages in Malta posing and waiting until I had finished my sketch of them before driving off.

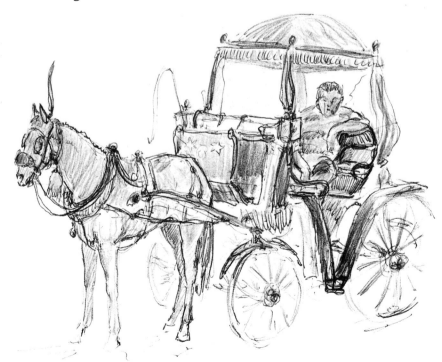

You must always sketch from life

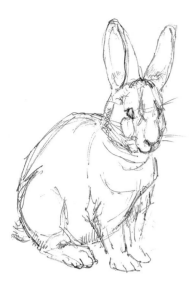

When working on an animal portrait, my sketchbooks are full of different poses, some just started with a few lines, and others taken right through to final detailed study from which the finished portrait is taken. I find it useful to do many different sketches of the animal and, of course, you have to be prepared to abandon a sketch and take it up again later if the animal returns to that pose. Fortunately, I find that most animals have certain poses to which they do often return, so that a drawing started and then abandoned may be continued later, and with luck, completed.

It is too much of a risk to make any drawings or sketches of an animal without an actual model in front of you – you should always try to draw from life. The best way to learn to 'see' and observe an animal properly is by putting down on paper what is actually there, rather than how you think the animal should look from photographs, because like humans, each animal is different! Photographs, too, can be misleading, because they may have been taken from an odd angle, or the colours may not be true, so be careful!

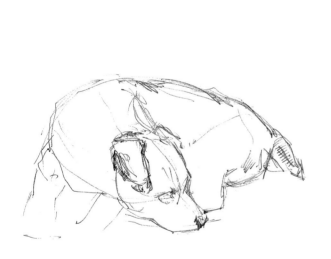

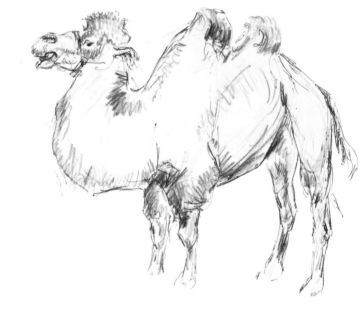

Animal subjects for sketching

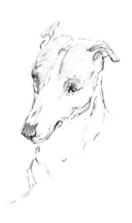

Dogs are my favourite animals for sketching and painting and, in fact, it is dog portraits that I am most often asked for. After dogs, in the popularity stakes for portrait commissions, come horses and cats, but for me, farm animals too are wonderful subjects for sketching – especially calves and pigs which I find particularly appealing. I am fortunate in living in a small village in the Cotswolds and I have fairly easy access to neighbouring farms, where I have several kind farmer friends who give me permission to draw and paint their livestock at regular intervals. Hens, cockerels, ducks and geese, too, are a delight to paint, with their interesting shapes and the vivid colours of their plumage.

When sketching animals I find that a large spiral-bound A3 size, 298 × 420 mm (11¾ × 16½in), sketchbook is best, as you can quickly turn the pages if the animal moves, because you do need a fresh

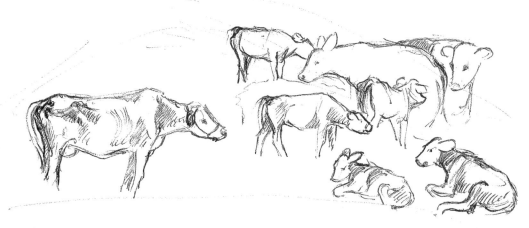

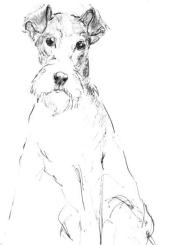

drawing every time the position changes. Also, I like a large page but it depends on the size you feel comfortable with. I do sometimes use an A4 sketchbook, 292 × 210mm (11½ × 8¼in), and a small pocket-sized sketchbook from time to time.

I use a variety of sketching materials, such as 2B–6B pencils and charcoal, but I prefer a ballpoint pen and different types of felt-tipped pens. I add colour to my sketches with conté, or coloured watercolour pencils, which I usually apply dry, without adding water. However, if I want a watercolour effect then I add washes of water to the coloured pencils and use them in conjunction with waterproof ink.

Generally, I use white paper in the sketchbooks, but I do sometimes also use coloured pastel paper, either grey, fawn, or beige-brown. Then I draw with black charcoal pencils, or coloured pencils, and pastels. I often write notes at the side to remind myself of certain characteristics and colours. I then use these sketches to work up into the final painting back in my studio, either in pastels or oils, depending on the client's choice of medium – and, also, occasionally, in watercolour.

Although it may seem extravagant, I find it is best to sketch on only one side of the paper, especially if you are using charcoal. If you use both sides for sketching, the sketches may smudge and spoil each other. Also, if you ever wish to remove a page from your sketchbook you will not lose two sides of drawings. If you are working out of doors with frequent movement of the sketchbook, and using charcoal or pastels, then do fix them with a suitable aerosol spray fixative. You have to be careful though, and use the fixative sparingly as it is apt to deaden the brilliance of the colours.

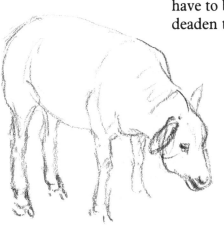

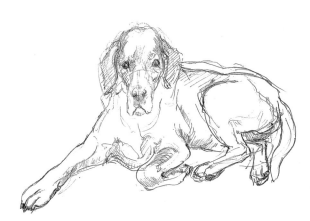

7

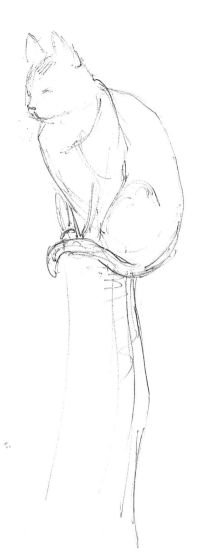

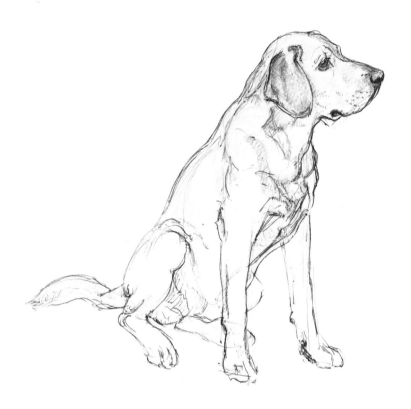

When I do animal portraiture work, I prefer to have 'sittings' in my own studio, but often do have to go to the owner's home. Dogs generally come to me but cats will not settle away from their own surroundings, so I visit them and, of course, I have to go to the owner's homes to sketch or paint horses and farm animals. I like to work a full day, say 4–5 hours with a break for lunch (both painter and subject need a break!). I find that it is best to have two consecutive days (or as close together as possible), so that I can build up the mental, as well as the visual, image of my sitter, as successful animal portraiture is all about capturing the animal's personality and character.

How to keep an animal still while sketching

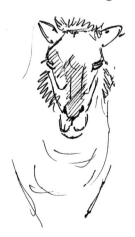

I am often asked how I keep an animal still, while I sketch. The simple answer is that you seldom can, or even if you could, the result would be stiff and lacking in spirit. A horse can be held still for a few minutes but cattle, although not seeming to move a great deal are actually constantly shifting around even while they are grazing, or waiting to go into the milking shed. So, you have to work very swiftly to catch their character and stance in a sketch. The same applies to sheep and, of course, goats, who are often very lively. Young pigs

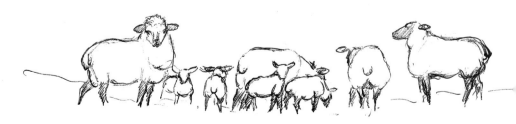

too, are maddeningly fast in their movements, suddenly dashing off at break-neck speed, charging around after each other and squealing with delight! Even seemingly staid adult pigs can move quite quickly when they want to.

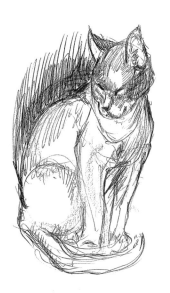

Cats are a law unto themselves, especially Siamese. If they are feeling lively, they will tear around the room, up over the backs of chairs and sofas, even up the curtains. When they come to rest, it is usually to curl up, faces hidden by their paws, a cosy ball of fur – but hardly good for a portrait, where faces and eyes are so important. This is where the owners come in; they may have to work hard to keep their pets attentive, yet fairly still. Dogs can be easier than cats but the owner's presence is often necessary to maintain a happy balance between activity and a quiet pose.

I remember one dachshund puppy – a real bundle of energy – who lived with his doting, elderly owner in a bungalow which had a long passage running between the sitting-room and the kitchen. I went every day for a week to their house to try to find a suitable moment to satisfactorily sketch this little dog. His chief delight was to race up and down the passage, and when tired of this he would leap on to his owner's lap and curl up with his back to the viewer and his head tucked under his master's arm. Most frustrating!

I began to think that I should never have opportunity of getting detailed enough drawings for a portrait when, on the last day, just as I was completely despairing, he suddenly heard the chink of a teacup and sat down quietly for a few moments listening, with his ears pricked. My opportunity had arrived. After so many false starts and unfinished sketches, he was at last imprinted on my mind and I was able to make a rapid, but correct, working sketch and get it finished before he was off again, up and down the passage!

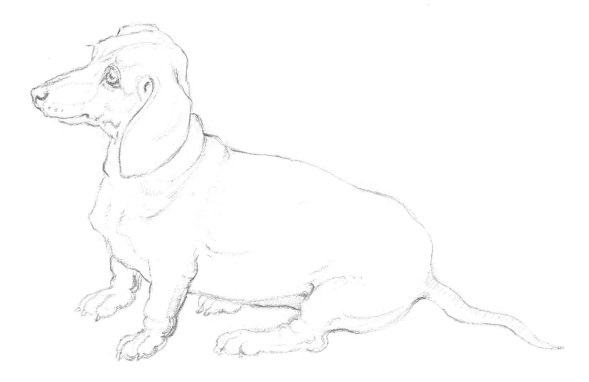

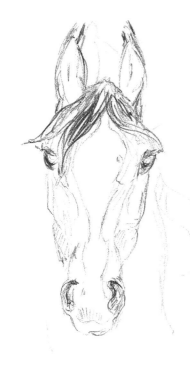

Fortunately, life is seldom as difficult as this, but it is true that constant practice makes the hand and eye work in unison. Mine is not a relaxing job but I must admit that I find it completely absorbing, and intensely enjoyable at times, too.

How do you persuade an animal to relax? For this you need to gain its confidence. The power of the human voice with animals has been known for years. In Victorian times, there was an Irish horse-breaker known as 'the whisperer'. It is said that he could calm a nervous and unbroken horse in a very short time by murmuring words softly in its ears, all the time gently stroking and caressing it around the eyes, ears and muzzle.

I always speak quietly and calmly to my animal sitters and they quickly settle. Animals don't like sudden movements, or loud voices. I give them plenty of time to get to know me, especially if they are in my studio – if I am sketching them in their own home it is, of course, much easier to relax them. The owner and I sit quietly while the dog explores the room by sniffing around. It sees us relaxing and soon feels at home. I also have a supply of titbits by me but I like to keep these for when the dog becomes bored. It is surprising how one biscuit, given in tiny pieces, can be stretched out over an hour, by which time I have made several sketches. After that time we have a break and the dog is taken out for a few minutes, while I stretch my legs. Horses, I find, are very partial to peppermints, but carrots or apples will sustain their interest for quite long periods, and are probably better for them.

Using my own dogs as models

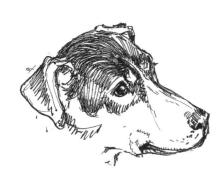

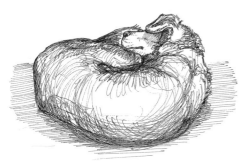

When I am giving demonstrations of animal painting to art clubs and societies, I like to take my own dog as a model. A few years' ago I used to arrange for someone at the club to bring their dog for me to draw and paint during the demonstration. Sometimes this worked, but often it didn't, because some dogs, however well-trained, just can't stand being stared at by a crowd for a long period. A dog needs to have a very 'outgoing' character to be a good model – I find that poodles are often very good sitters, whereas like humans, some dogs may be shy, nervous, or just plain disobedient. So I found this arrangement too much of a hit and miss affair. It is difficult enough for an artist to make a portrait in a limited time, with fascinated onlookers watching every move, without having to try to control the model at the same time!

And so I decided to train my own dog as a model. My previous dog, Dodie, a Beagle, was a splendid model and when she died I was bereft. Now Tess, my collie/whippet cross, has been trained and she is very good. When I go to demonstrations she jumps up on the table in front of the students, looks round once or twice, and then lies down quietly to be sketched. Also, Tess is a good subject because she has a smooth, glossy coat and beautiful black, tan and white markings which stand out well for an audience to see at a distance. Here are some sketches of Tess, and colour sketches of Dodie can be found on page 33.

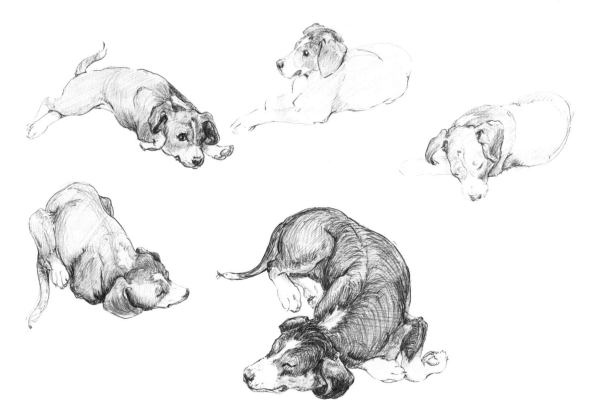

So, if you are interested in sketching animals I suggest you start with your own pet. You will already have a mental image of its character and you will have plenty of opportunity to sketch it when it is sitting or lying quietly. If you don't have your own animal you may know a friend or neighbour who has a pet.

Capturing the personality of an animal

Imeet many animals in my work as an animal portrait artist and I am often asked what makes one animal stand out in a crowd. In fact, only certain ones do stand out in my memory as real personalities. To me it is not just a question of looks, but character as well. The animal need not necessarily be handsome, or even well-bred, but there must be a certain 'something' that makes it different from the others.

I remember that funny little dog I saw in Spain. . . . He was an endearing, rather nondescript terrier puppy – small, scruffy, with short legs, rather 'off-white' in colour but with odd patches of black here and there. But he had the most extraordinary ears! They stood up like a couple of fans with a halo of black-tipped hair all around them. He lay in the sun in the middle of the little square, watching the people go by, and the light shimmered through his long hair.

'Perry' is a jaunty Cavalier King Charles Spaniel I was asked to paint. He is mostly black, with white legs and dots of brown above his eyes. But it was his eyes that were so arresting and gave him so much character. These expressive eyes would gaze earnestly and unblinkingly into yours, willing you to do what he wanted. It was difficult to resist such an appealing look. He showed great interest in looking around my studio when he came for the preliminary sketches for his portrait. Then he sat quietly on his owner's knee, but when

coffee and biscuits arrived he arranged himself in front of me and stared at me long and hard, hoping for the odd biscuit or two. He held his gaze, and his position, for so long that I was able to make, and use, several very successful sketches. He was, of course, rewarded with a biscuit at the end!

Another 'character' I had to paint was Donna, the German Pointer. Among her many accomplishments, (she is a highly trained guard dog and has worked with distinction in the past for the Services) Donna has a remarkable ability to retrieve. And she retrieves quite useful things like £ notes! Recently she brought her surprised owner several of these, one at a time, carefully putting them in his hand. He had no idea where she was getting them from, nor did the police, when he took the money to them. After a search of the area the police suggested that perhaps the money might be used to buy Donna a supply of her favourite food!

Some dogs are inseparable, and two Jack Russell terriers I was asked to paint were always together. In fact they almost echoed each other's movements in everything they did. If Spot jumped up on to the window seat to look out of the window, then Snoopy would be there too in a couple of seconds. Their heads would turn from side to side in unison, and if one jumped down, then the other would follow suit. They really were a 'double act' and when I was working on the preliminary sketches for their pastel portrait, I would arrive at the house in a flurry of excited dogs, each vying to outdo the other in noisy welcome. But after the first hour, they would generally settle down, usually by a radiator, or together in one of the armchairs. They would arrange themselves in delightful positions, making lovely group poses, but one had to work very fast to capture those sometimes fleeting moments (see left and below).

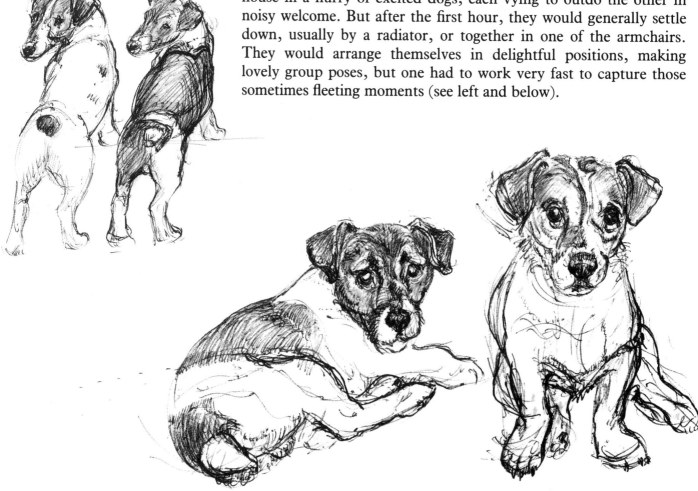

12

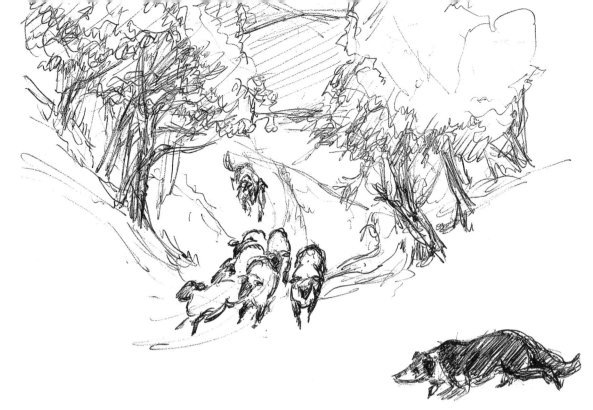

Sketching around the farm

There is a wealth of sketching material around the farm, if you are lucky enough to have access to one. If you are interested in painting farm animals most farmers will give permission for you to take your sketchbook or painting gear into their farm, as long as you don't get in the way and only go where they tell you.

Sketching farm animals can pose problems, however, especially if they are housed in a restricted space, such as a loose box or a byre, as there is often not enough space, or light. A calf shed, for example, is often divided into partitions so that each calf has its own cosy area, separated from the next animal by hurdles and straw bales. These partitions can be rather cramped and can limit your view of the animal you are sketching. So try to find a farm where the animals have roomy quarters.

If there are several calves in the same loose box with no divisions, the animals often come together and form attractive groups. The

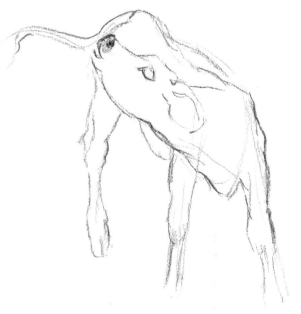

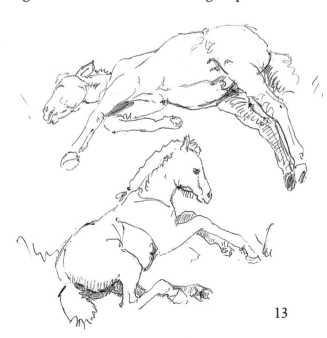

interior of these farm buildings themselves are interesting to paint, with their white walls and subdued light, the air hazy with straw dust, reflecting golden and brown. The food troughs and hay racks also make attractive shapes to sketch.

In the restricted space it is seldom easy to put up a painting easel, so this is when sketchbooks are so useful. A stiff-backed sketchbook can be steadied on the side of a partition, or a barn door, or if you are sitting down, on your knee. I usually make a number of quick sketches alternating from one animal to another if there are several together, as the animals constantly shift around. However, you will find that they often return to certain poses so that you should be able to do some finished drawings.

It is as well to remember that young animals especially are apt to be nervous, so that any sudden movement on your part may cause them to jump. Quiet, slow movements will help them to adjust to your presence, and then you may find that they are so curious and relaxed that they may crowd round trying to lick your pencils!

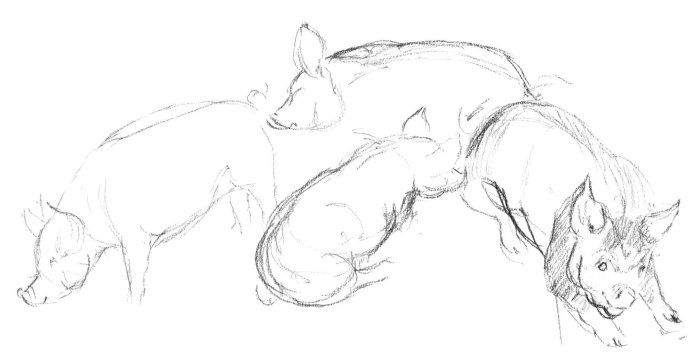

Young animals are companionable and enjoy crowding together, often making attractive groups. Piglets particularly like to lie around in heaps, but if one moves they may all suddenly jump up and leap off, scampering around the field, or sty, and you will have to start your group all over again. One thing you learn while sketching animals is patience!

Before you start sketching on a farm, I always find it useful to spare a little time to walk around and get the feel of your surroundings and subjects so that you know how best to portray them.

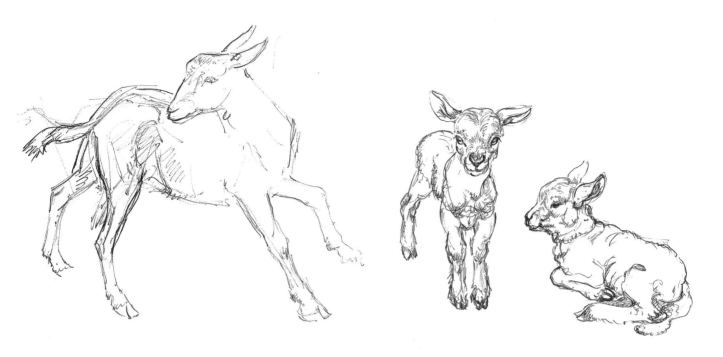

Near me is a farm with a family of white goats. When the kids are born they look very similar to lambs, but are less rounded in shape. It is interesting to note their very large knee and hock joints, and their long, thin ears. Compare the babies with their mothers, who are extraordinarily lumpy and angular in shape, with their hip bones sticking out oddly from their otherwise quite bulky bodies. Sheep are much more compact in shape than goats. It is a useful exercise to compare the shape and proportions of different animals in this way, because that is how we learn to distinguish differences which we don't see at a first casual glance.

A basic knowledge of anatomy helps

A basic knowledge of anatomy is a great help when sketching animals – or humans, for that matter. The underlying similarities are interesting to compare. For instance, we all have a skeleton which is covered with muscle, skin and hair, but where the species have evolved differently, so the various skeletons have developed in different ways. Compare the skeletons of a horse, cow, dog and cat, either in a natural history museum, or in books on the subject. The human skull differs in size from a dog's, but they both have eye sockets in which the eyeball rests, and upper and lower eyelids. They both have noses, but the nostrils are shaped and spaced according to their needs. Man, like some monkeys, has learned to walk on his hind legs, while the front legs have become arms, whereas quadrupeds use all four legs for walking. One of the most important areas of difference between the human and animal skeletons is the position of the knee and ankle on the back legs. The quadruped's knee is up by its groin, and what would be the ankle in a human, is half-way up the leg of the quadruped, so that the joint bends back on the hind leg, not forward as with the human being. This is often quite difficult to portray and is a common mistake when drawing animals.

Heavy horses are good subjects

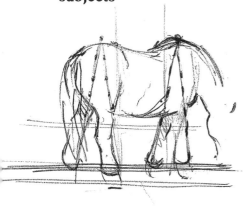

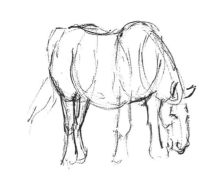

Among my animal favourites are heavy horses, particularly the Shires and Clydesdales. Perhaps this stems from my childhood memories of Manchester, where some still cobbled streets used to echo to the clatter of their iron-clad hooves.

I remember one day very vividly. The rain was sending rivulets of muddy water cascading between the stone sets, where my father and I were waiting to cross the road through fairly thick trafic. Beside us a flat-topped, four-wheeled dray came to a halt where the brow of the hill intersected with another road. The horse-drawn dray was heavily laden with large bales of cotton jute from the local cotton mills and the two huge Clydesdale horses, each standing about 17 hands high from the shoulder, were tossing their heads, making the beautifully polished brasses on their harnesses clink and jingle.

The carter gave the horses the word to start again. They heaved, stamping their great feathered hooves, and then, in order to gain extra momentum to pull the heavy dray, reared up in unison to throw their weight into their collars. They came down on the road with a crash, their iron-shod hooves sending up showers of sparks on the wet cobbles. They struggled and then the heavy dray was on the move. The carter sprang up on to the shafts as the horses gathered speed up the hill and they clattered away into the murk. This left quite an impression on me and it is an image I have never forgotten.

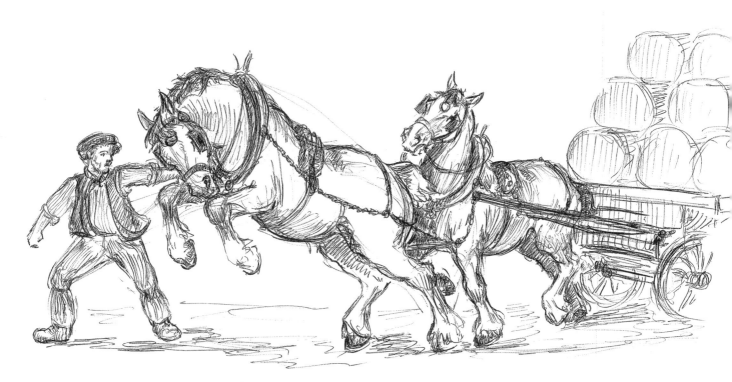

Nowadays heavy horses are still sometimes seen in city streets pulling brewery wagons. These fine and beautiful horses make a lovely subject for a sketch. Or, you can go to agricultural shows where heavy horses often appear, proudly stepping around the ring, sometimes to music. And, of course, there are always the big horse shows which often have a heavy horse section.

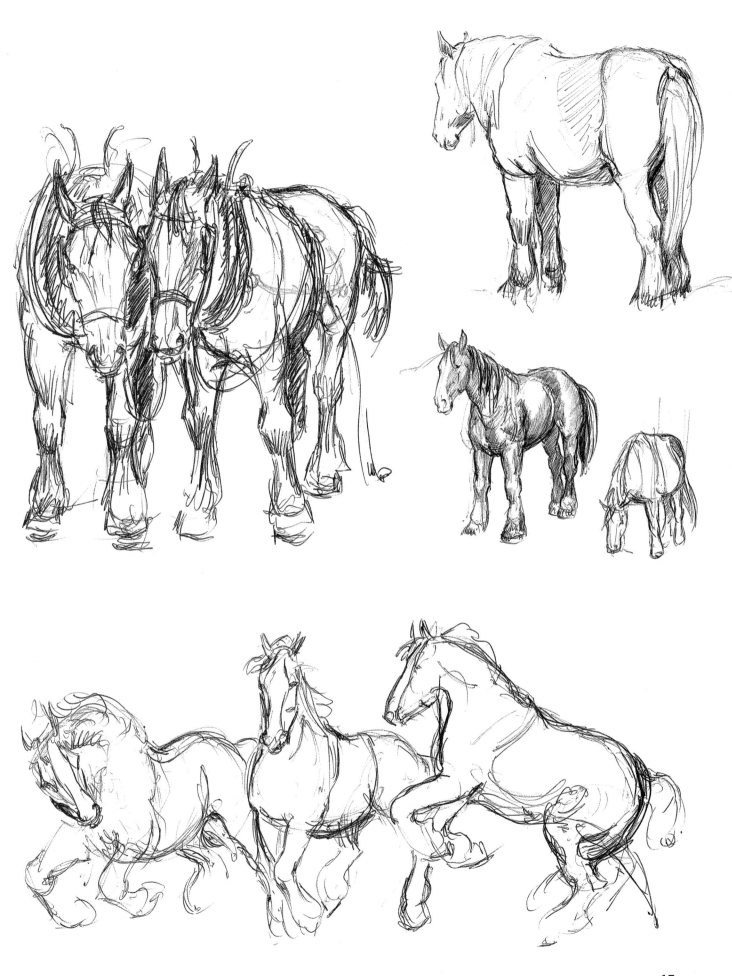

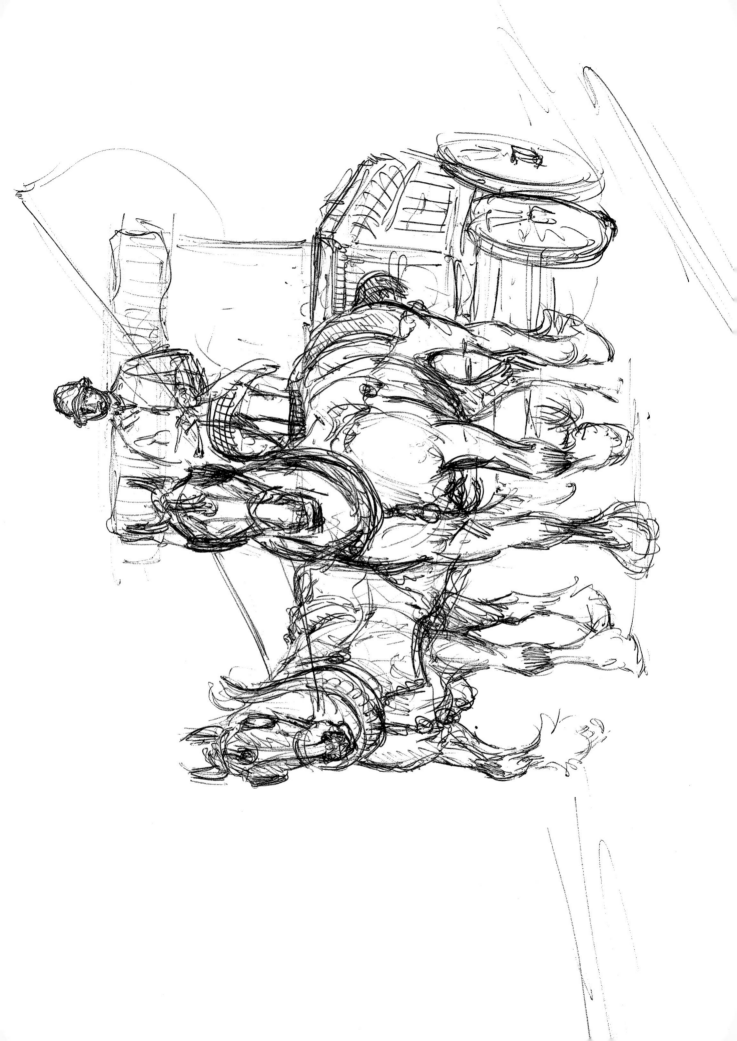

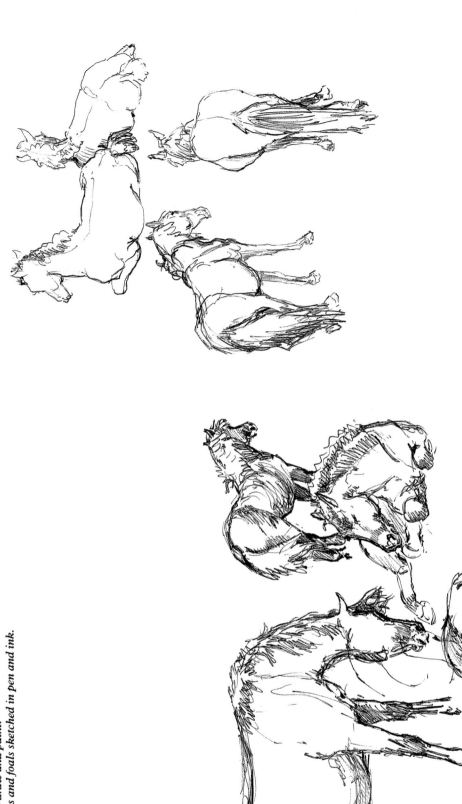

ABOVE: *This is a preliminary pen and ink sketch for an oil painting of Shire horses pulling a dray. I find heavy horses, with their controlled weight and power, fine subjects to draw and paint.*
BELOW: *A group of Exmoor mares and foals sketched in pen and ink.*

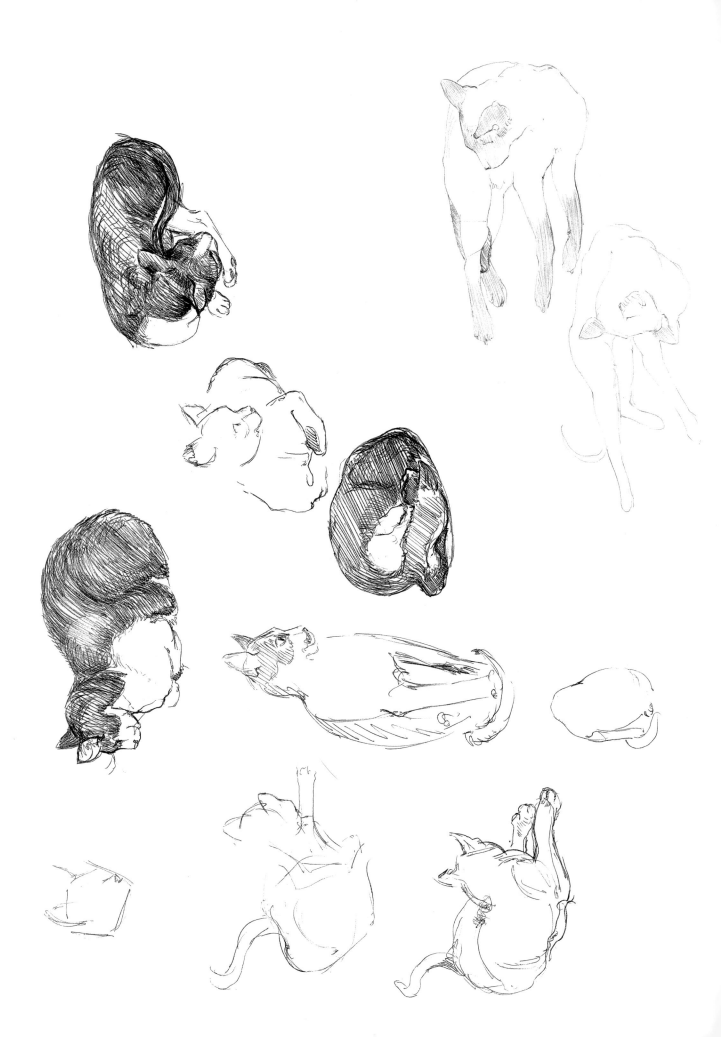

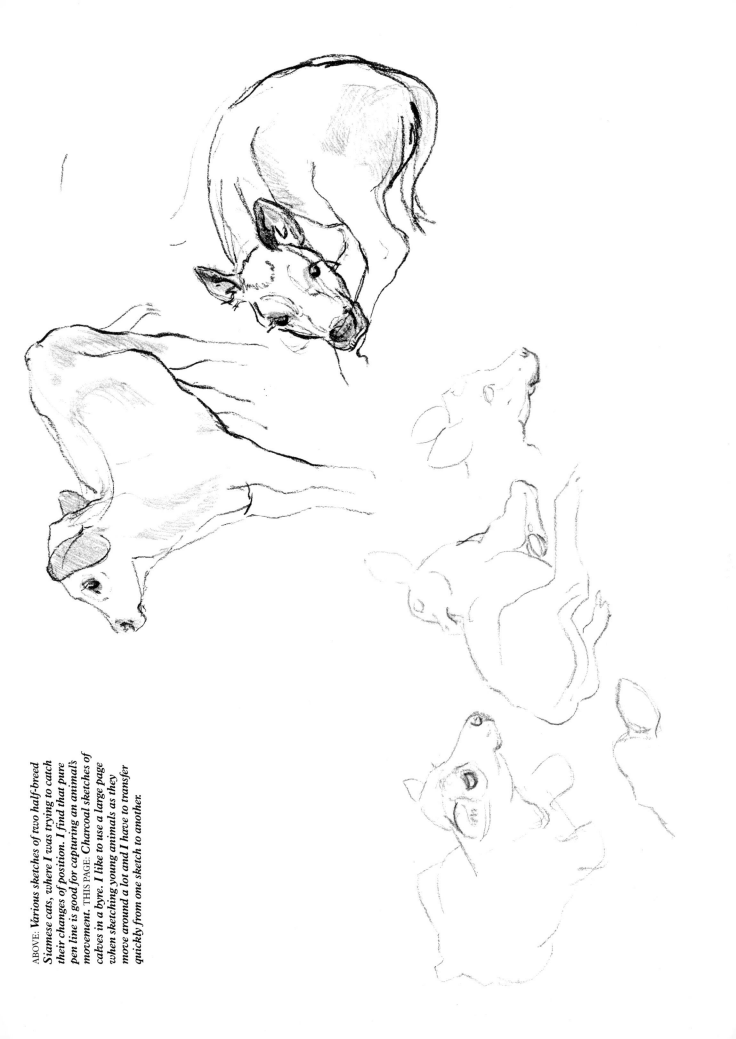

ABOVE: *Various sketches of two half-breed Siamese cats, where I was trying to catch their changes of position. I find that pure pen line is good for capturing an animal's movement.* THIS PAGE: *Charcoal sketches of calves in a byre. I like to use a large page when sketching young animals as they move around a lot and I have to transfer quickly from one sketch to another.*

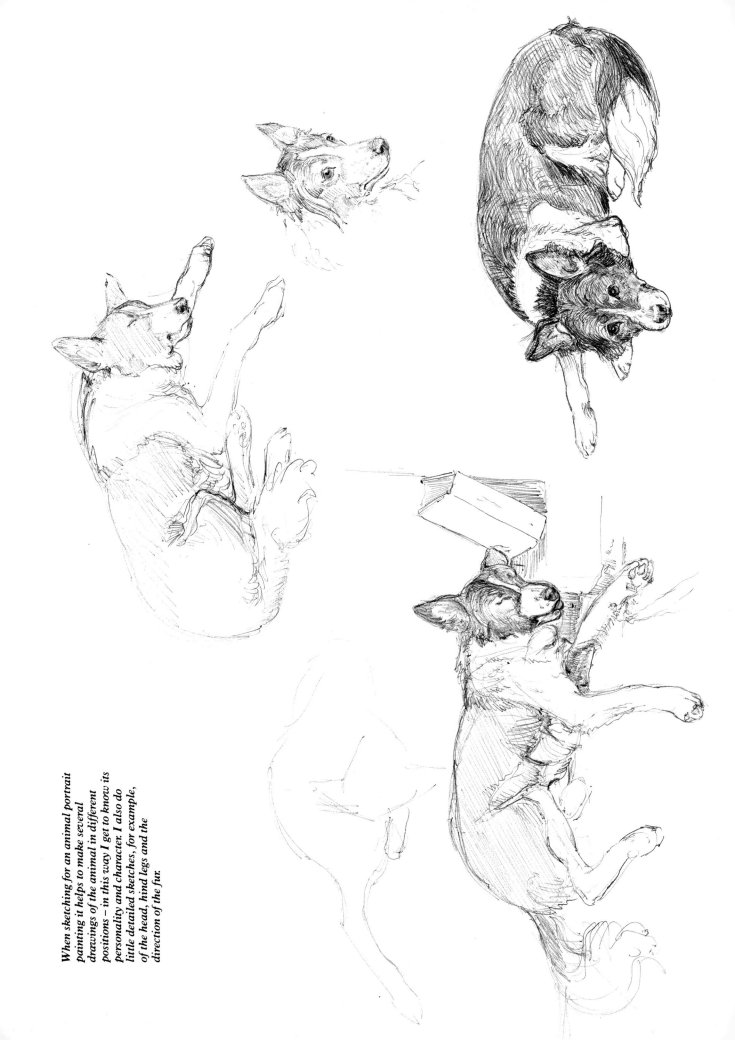

When sketching for an animal portrait painting it helps to make several drawings of the animal in different positions – in this way I get to know its personality and character. I also do little detailed sketches, for example, of the head, hind legs and the direction of the fur.

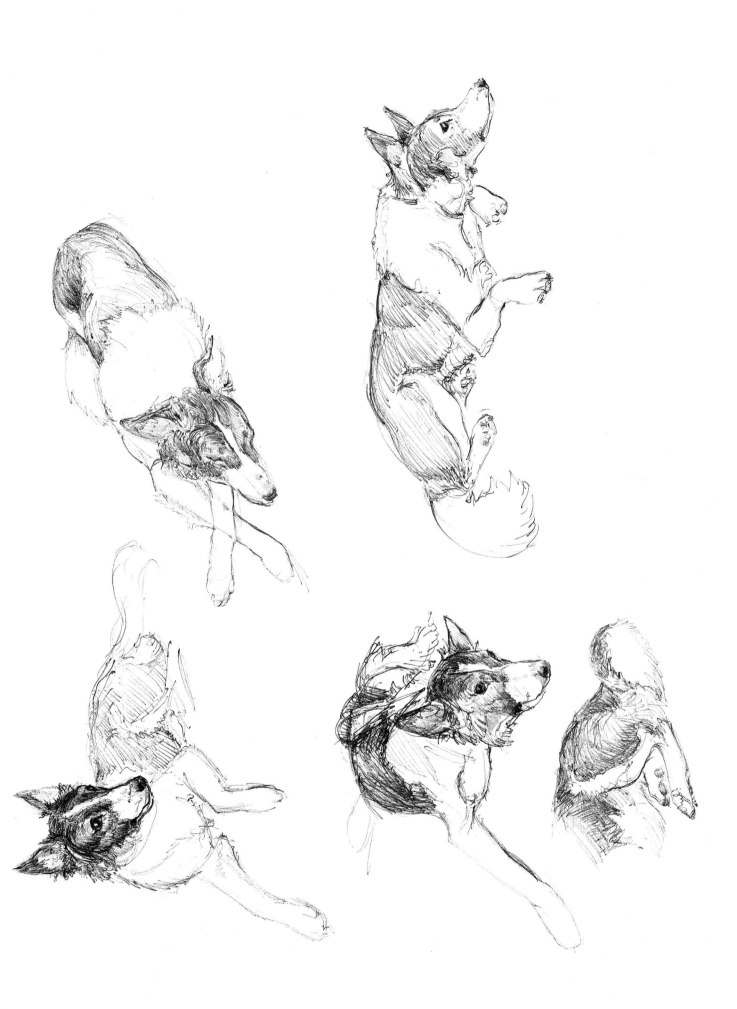

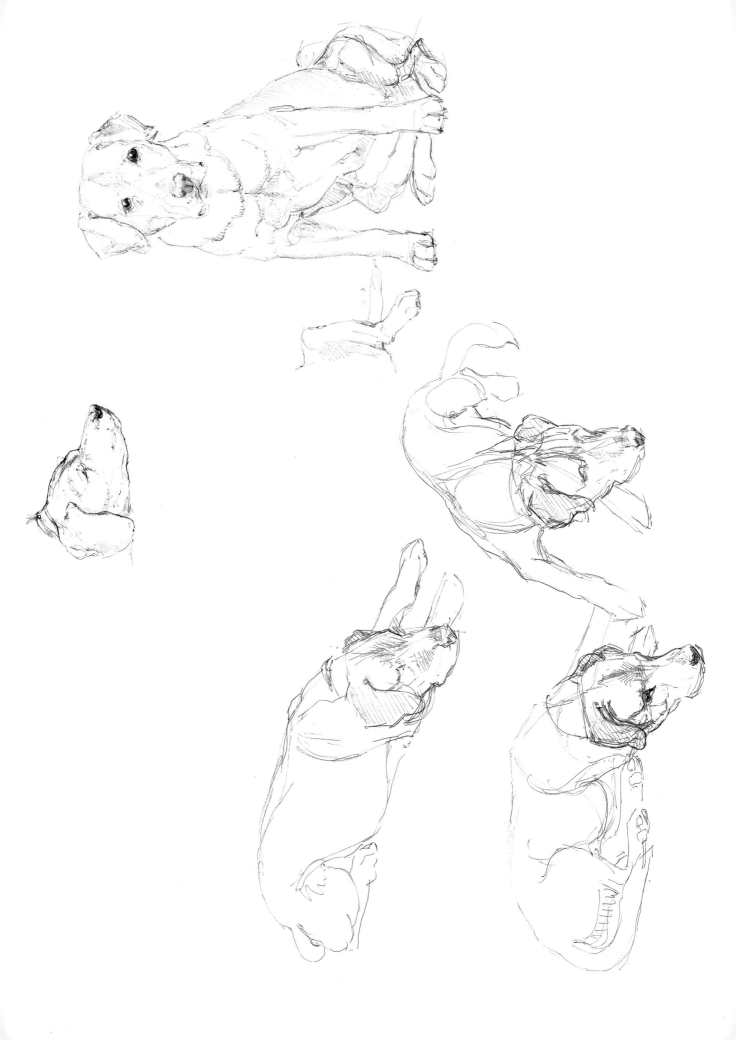

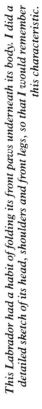

This Labrador had a habit of folding its front paws underneath its body. I did a detailed sketch of its head, shoulders and front legs, so that I would remember this characteristic.

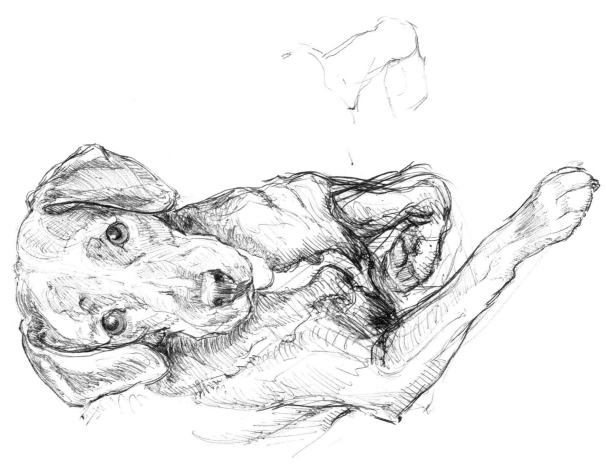

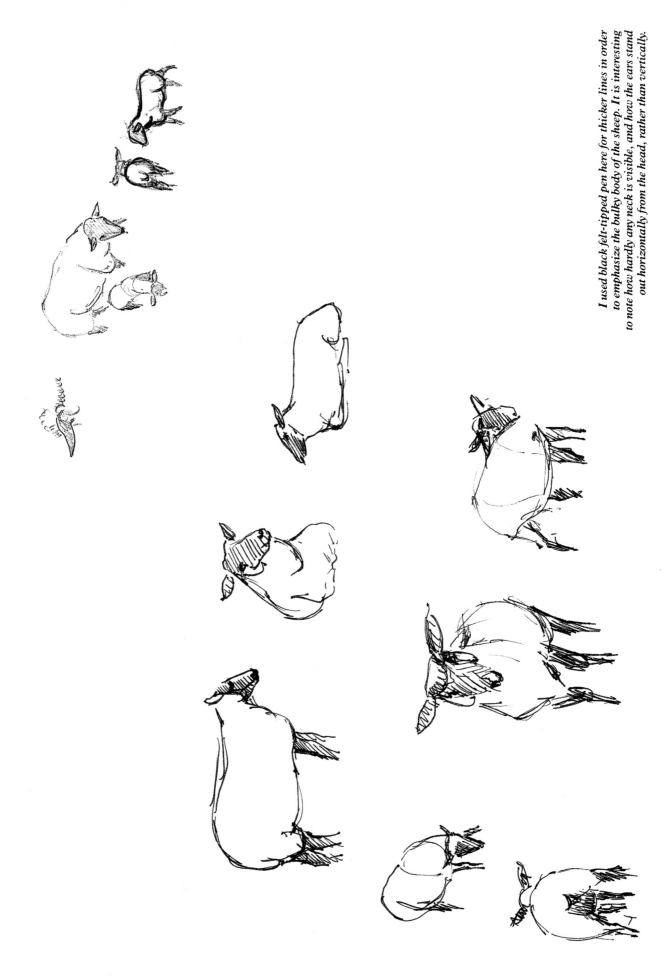

I used black felt-tipped pen here for thicker lines in order to emphasize the bulky body of the sheep. It is interesting to note how hardly any neck is visible, and how the ears stand out horizontally from the head, rather than vertically.

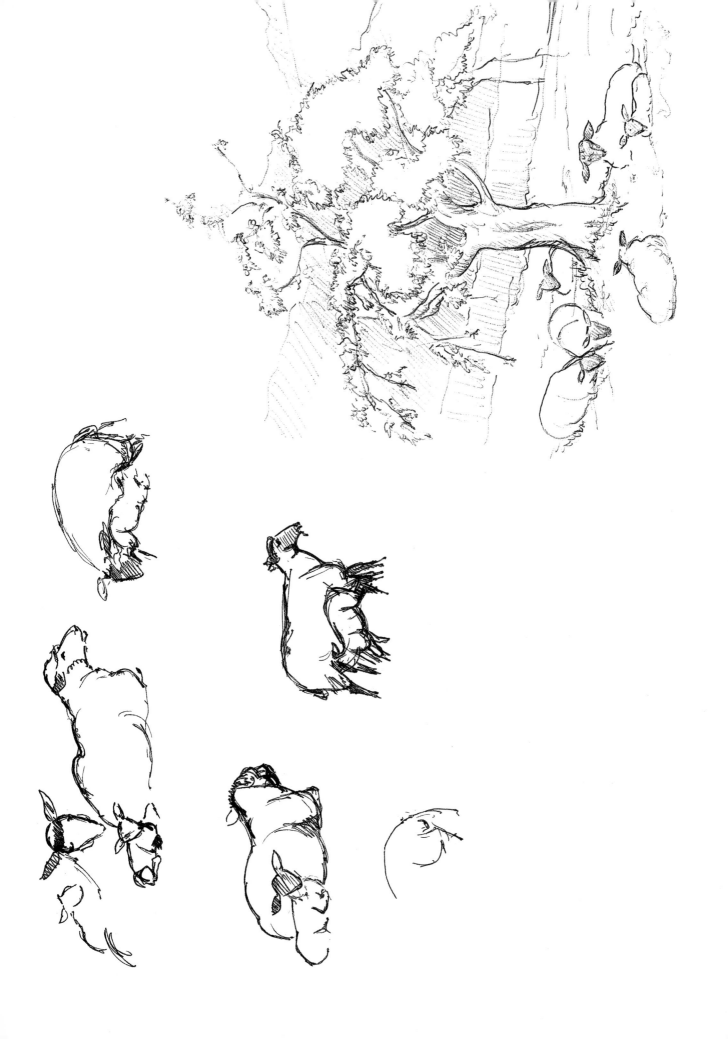

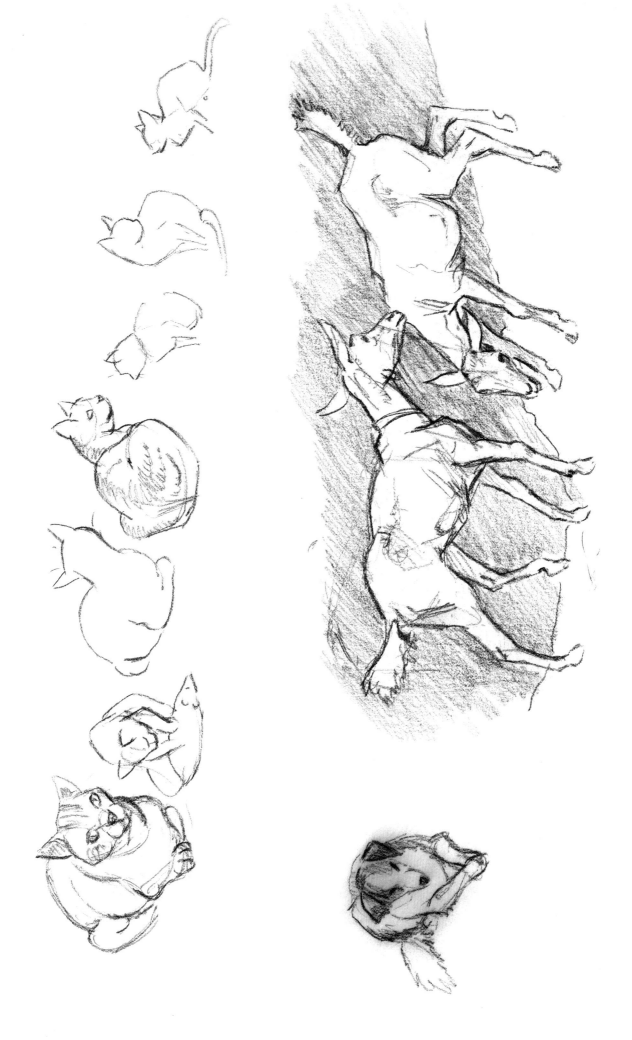

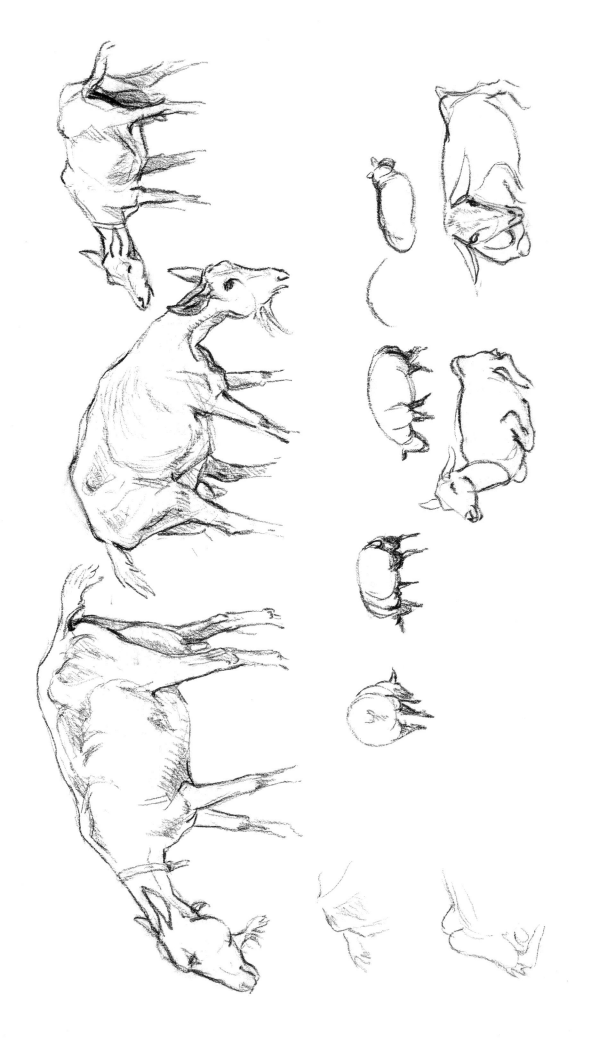

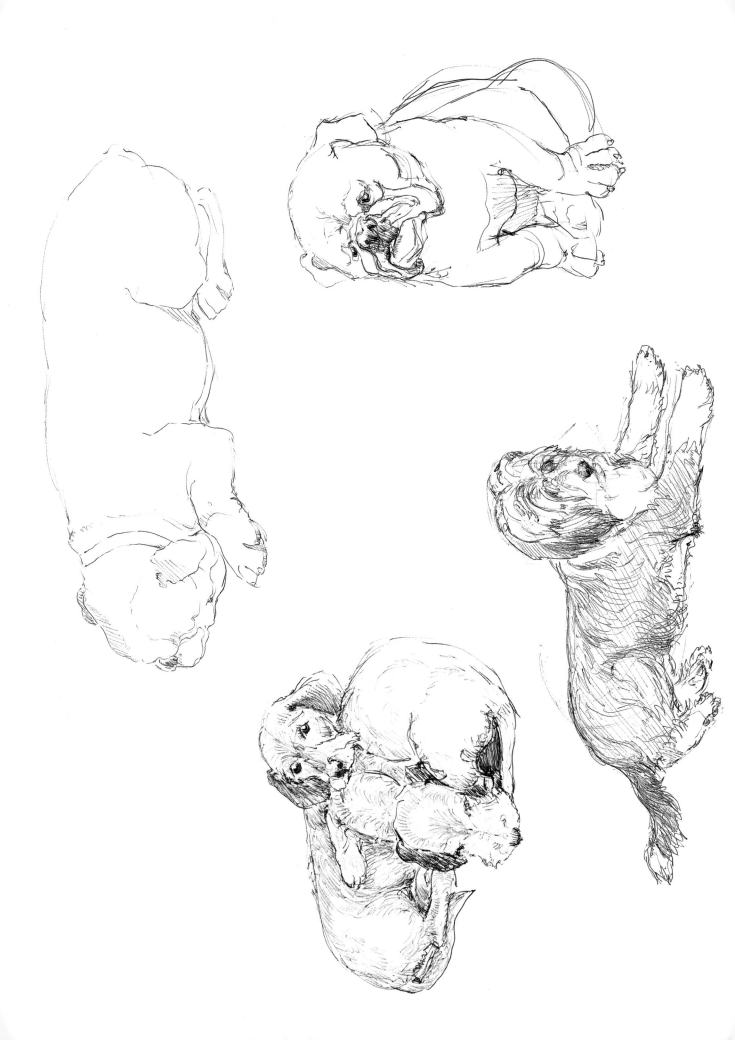

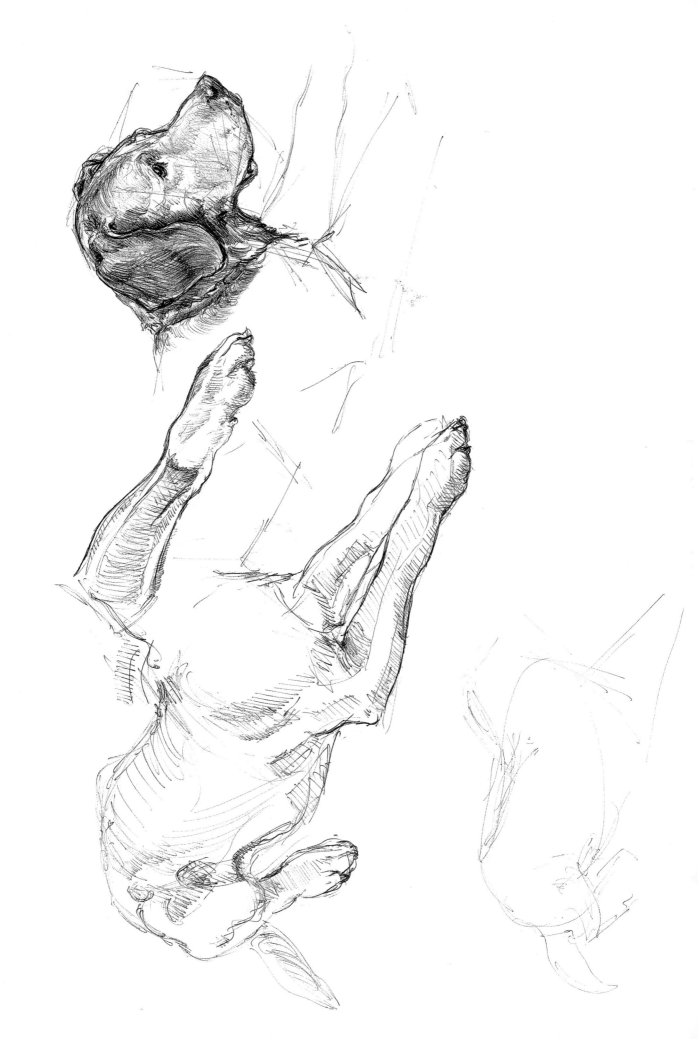

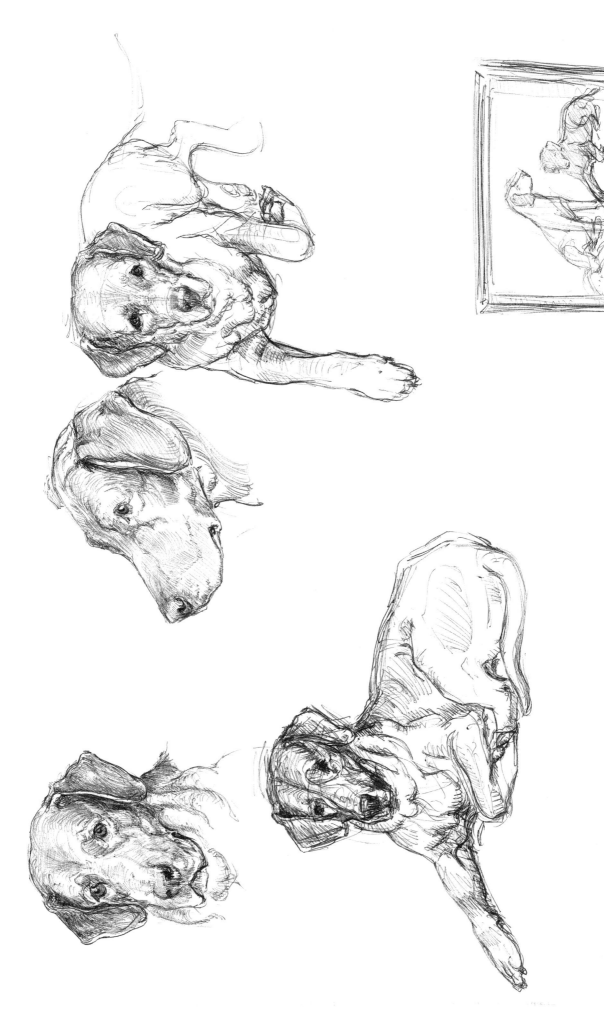

You will see that I did several pen and ink sketches of the two dogs before I was happy with the final composition for the painting. I find it always helps to put a frame around the subject, when composing a group portrait. BELOW: *These colour sketches are of my previous dog, 'Dodie'. I added coloured conté crayon to pen and ink, which immediately livens up the sketches.*

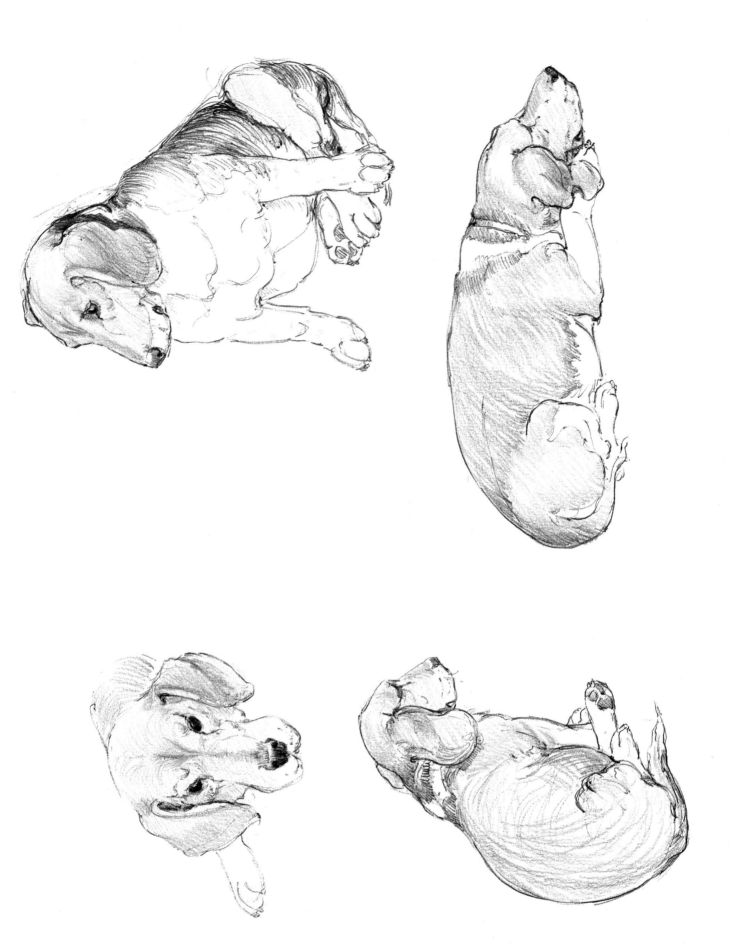

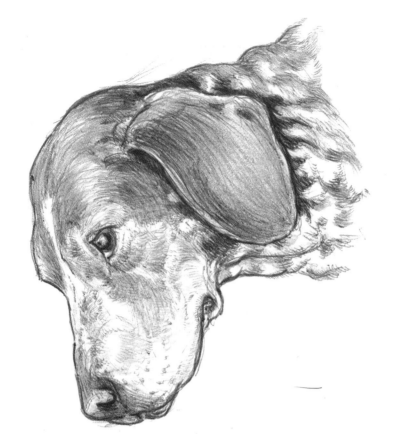

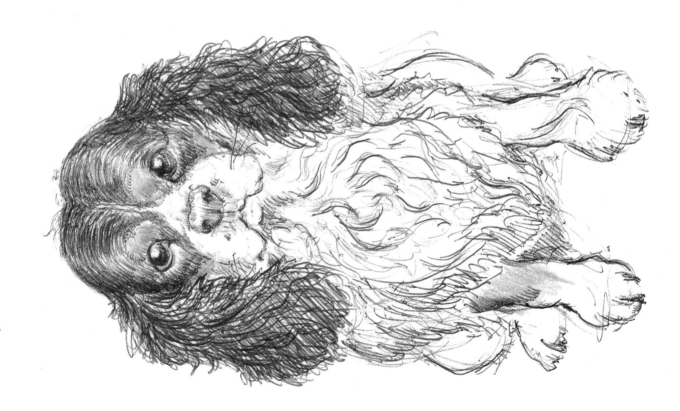

These are colour sketches of the King Charles Spaniel 'Perry' and 'Donna', the German Pointer, both of whom were mentioned in the text on pages 11 and 12. I have used pen and ink with coloured conté crayon for both sketches, which were then worked up into painted portraits – a pastel of 'Perry' and an oil of 'Donna'.
BELOW: **This beautiful Pekinese with its luxuriant, silky hair made a good contrast with the powerful smooth-coated Bulldog. Both were sketched at Crufts Dog Show and the Bulldog was that year's winner.**

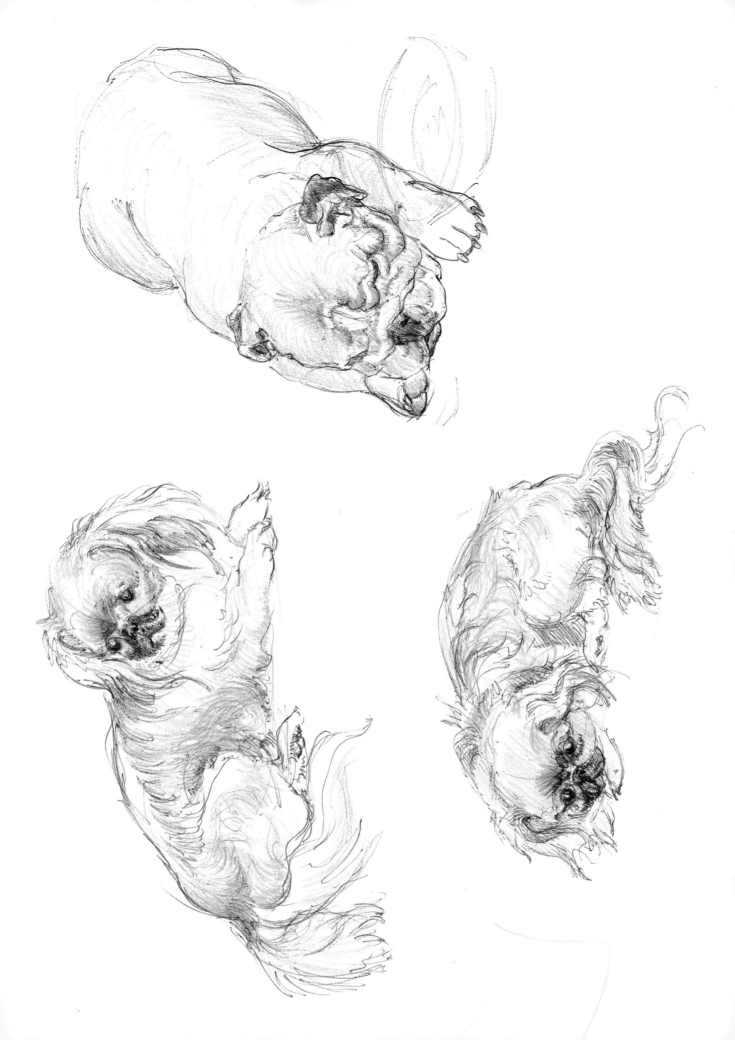

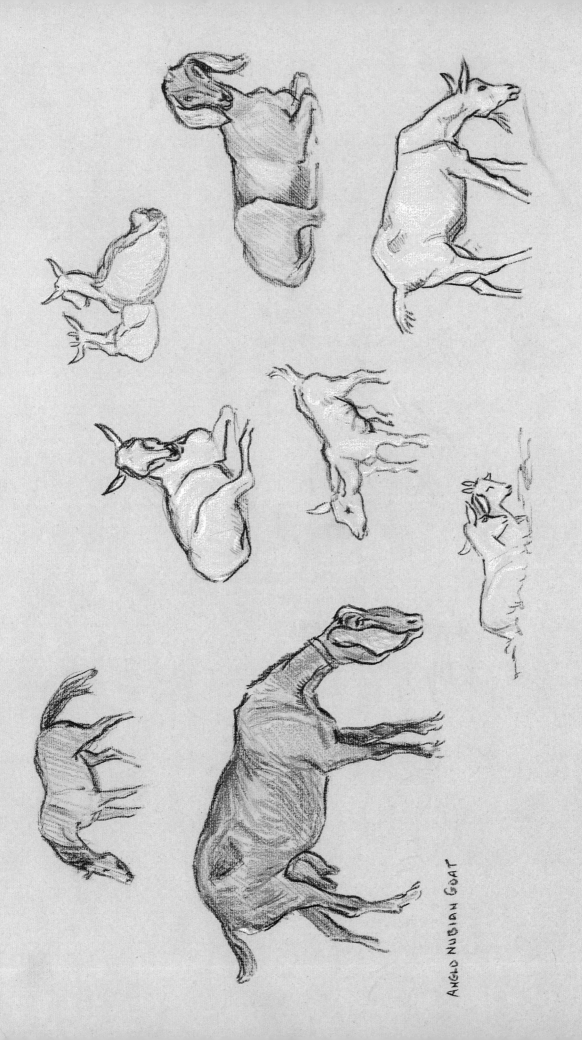

ANGLO NUBIAN GOAT

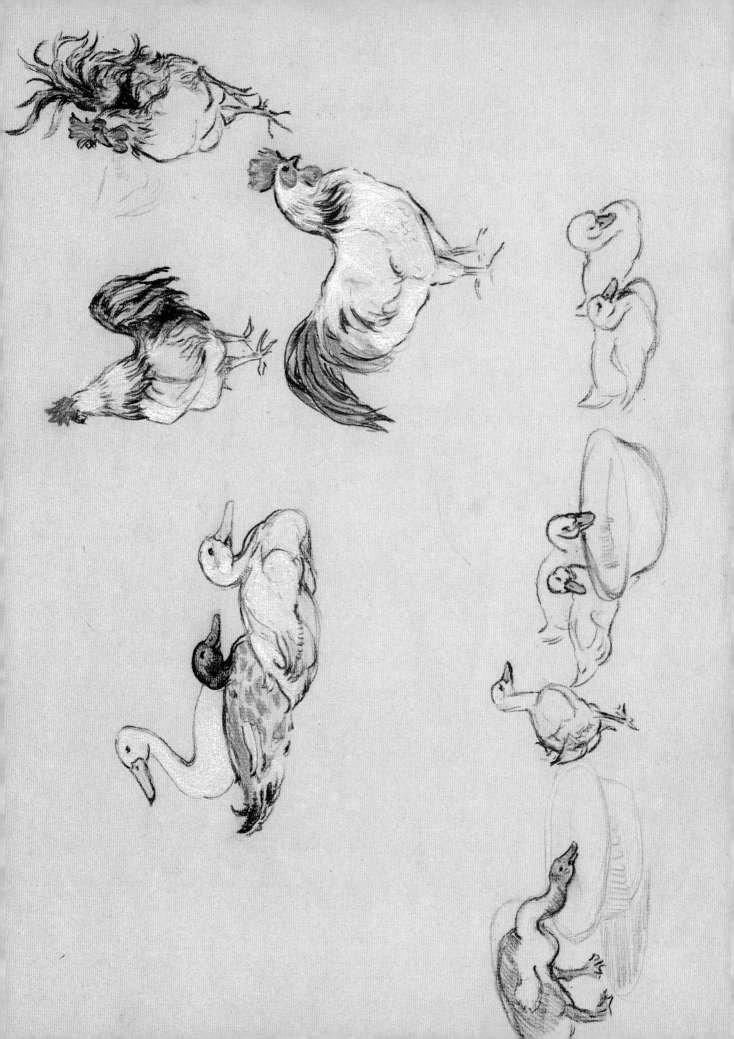

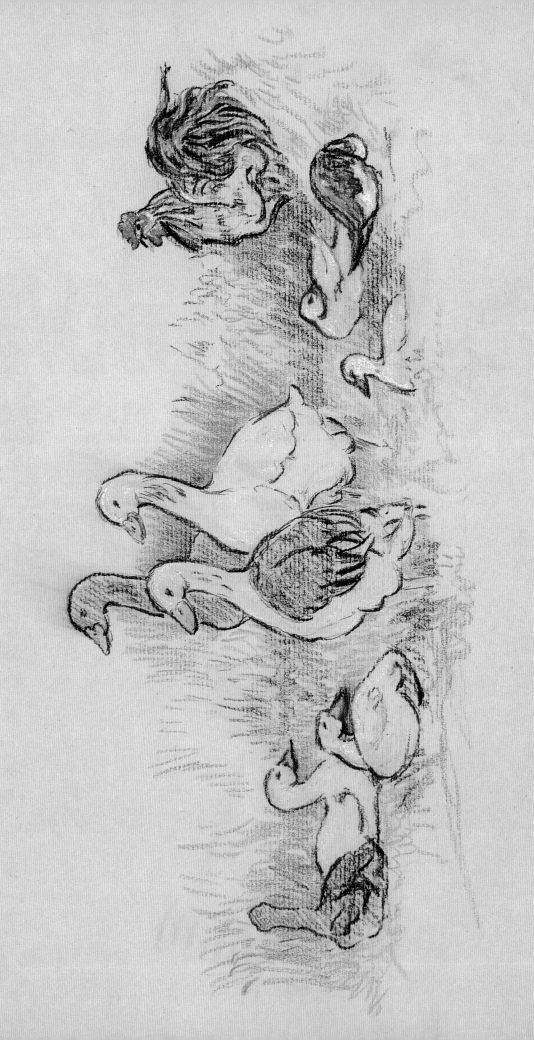

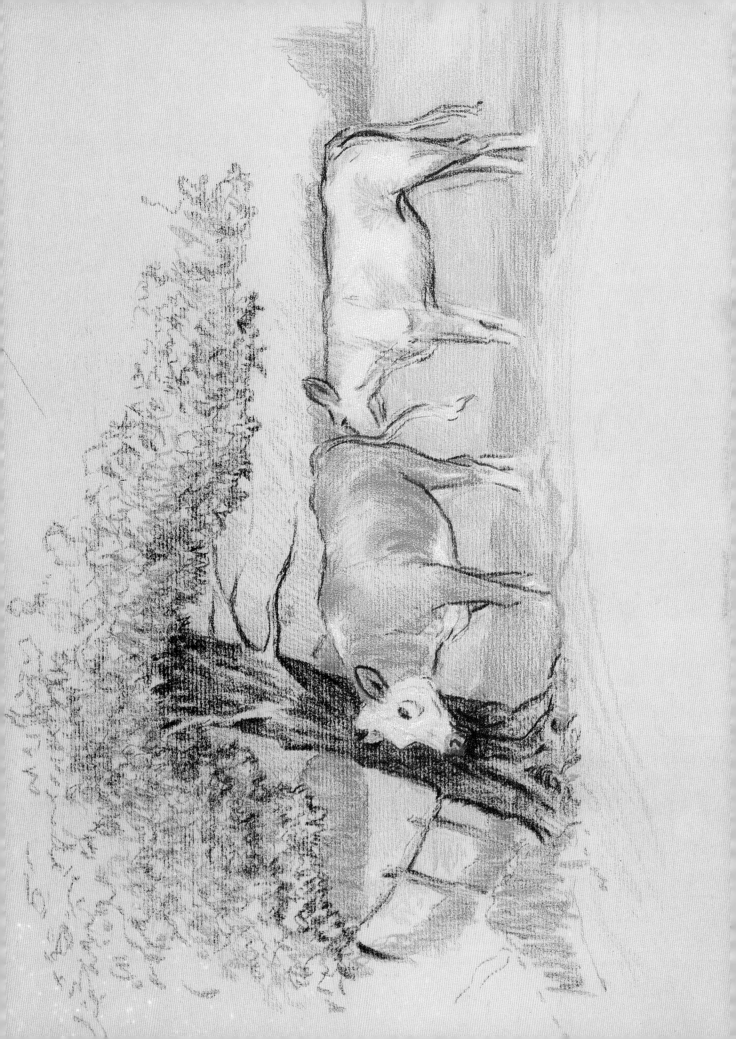

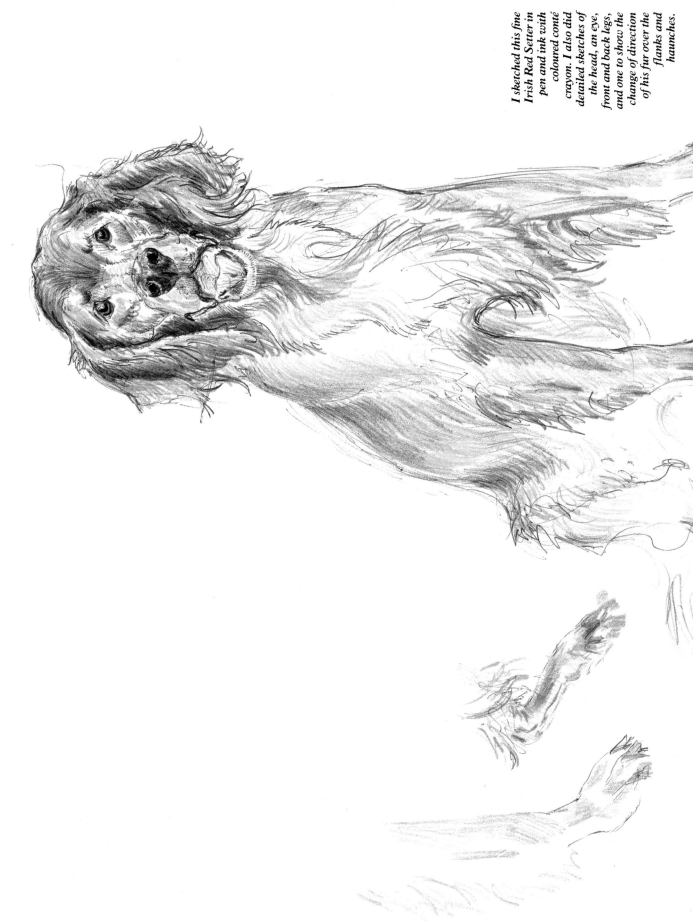

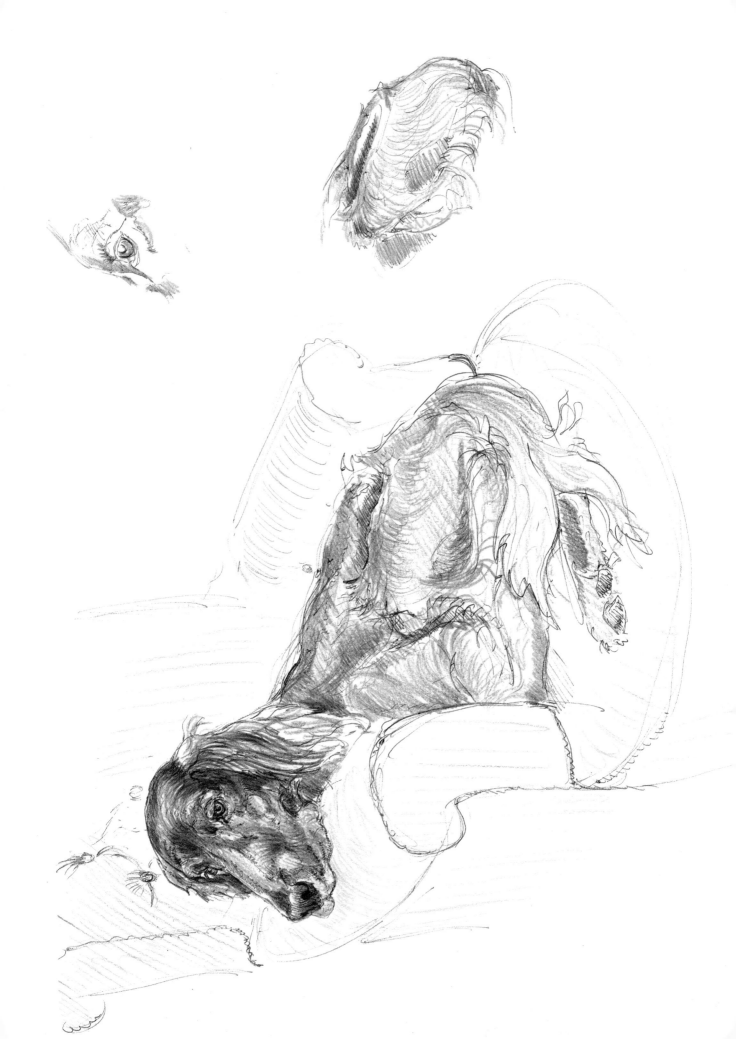

Here are my attempts at arranging two dogs to make an interesting composition. These Jack Russell terriers were also mentioned and illustrated on page 12. All sketches are in pen and ink, with coloured conté crayon.

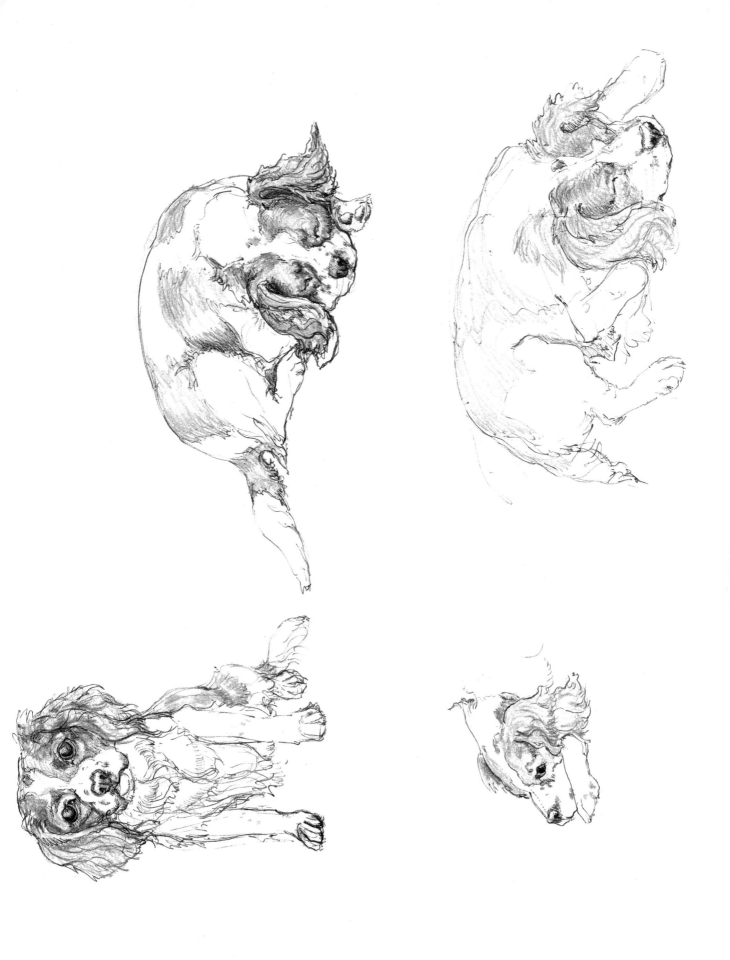

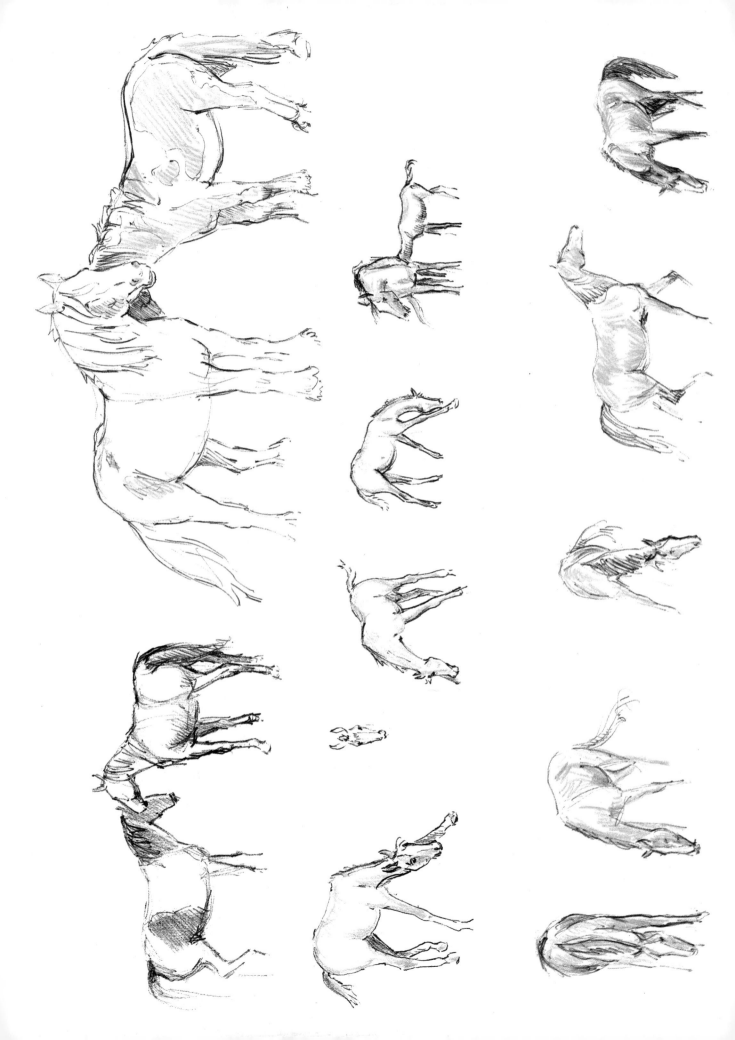

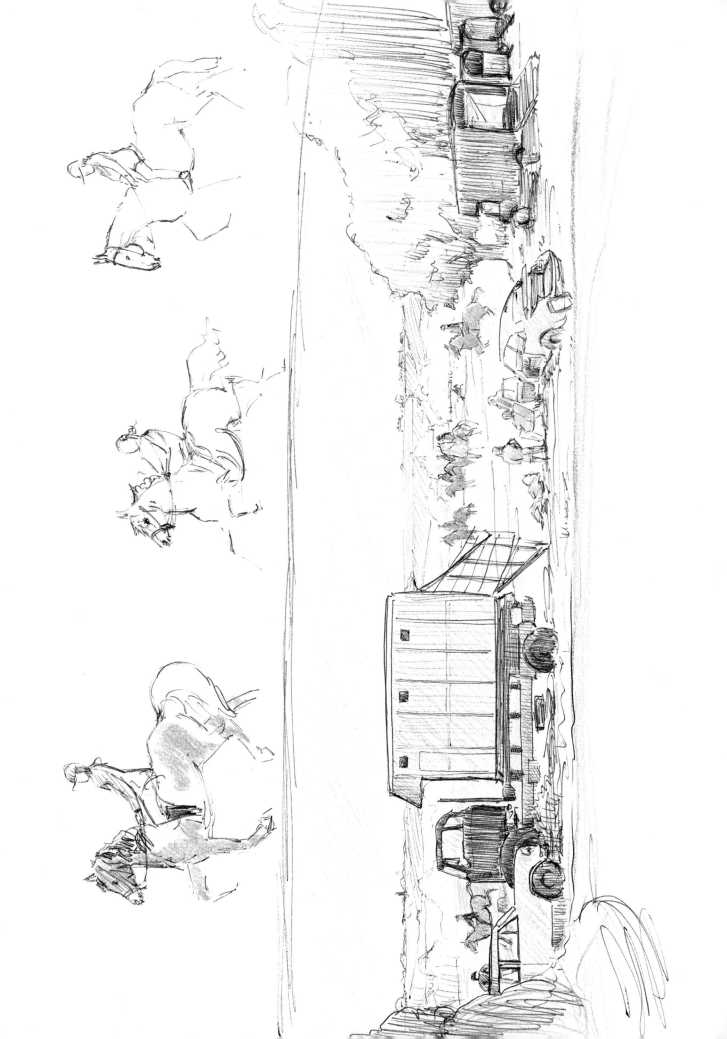

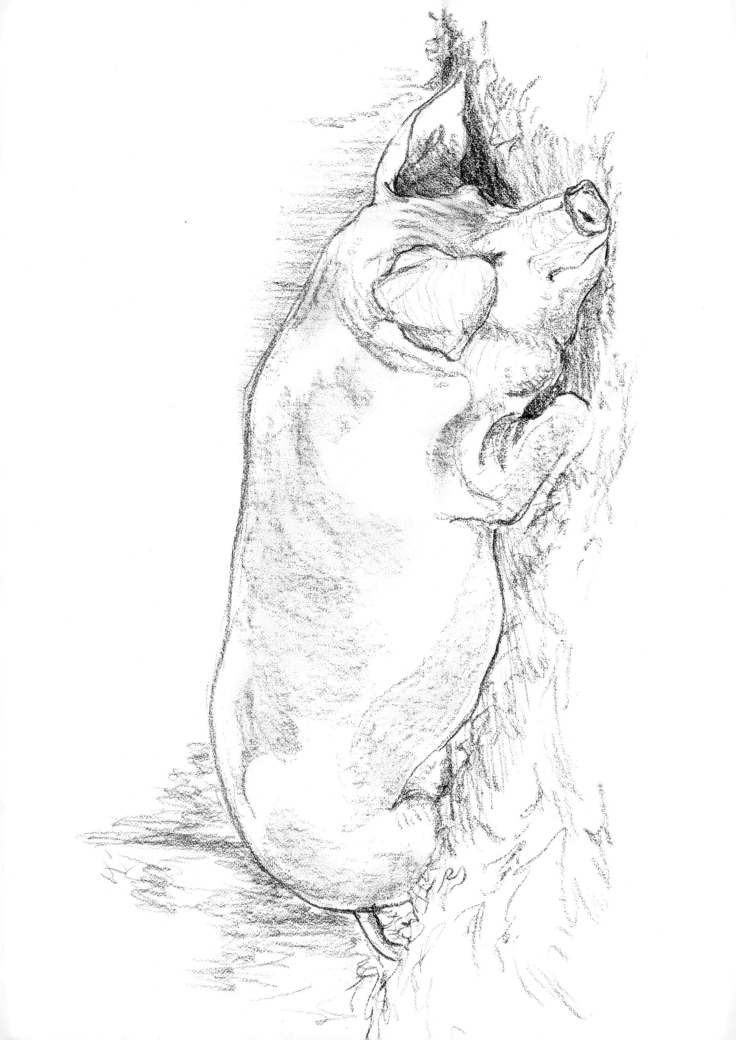

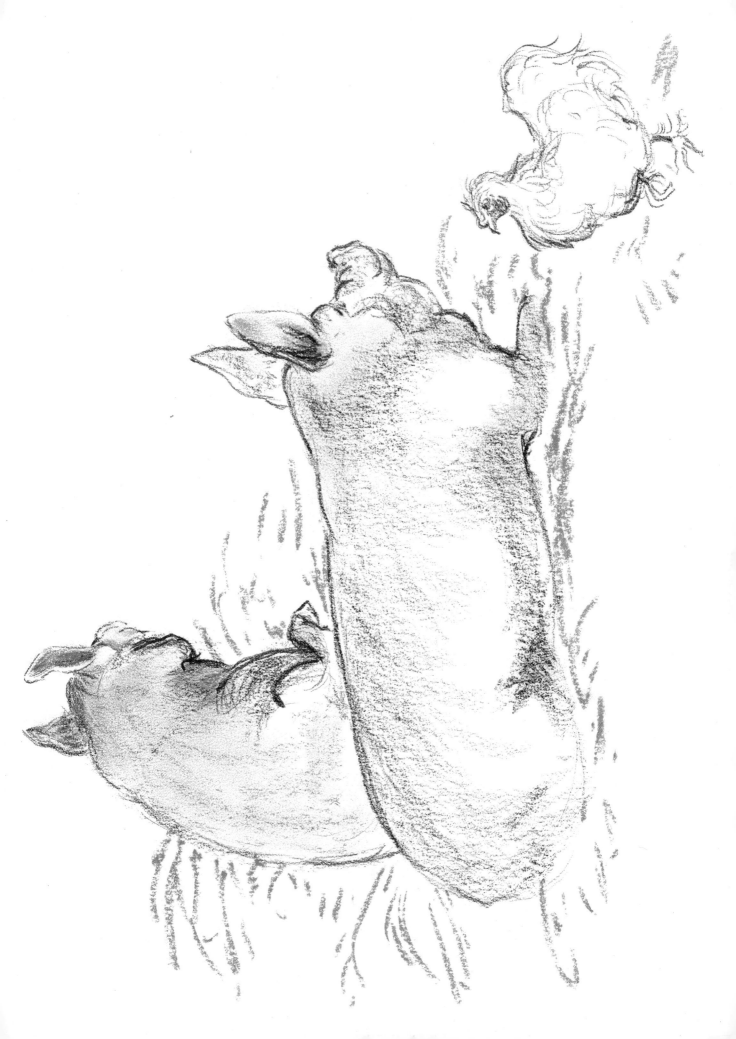

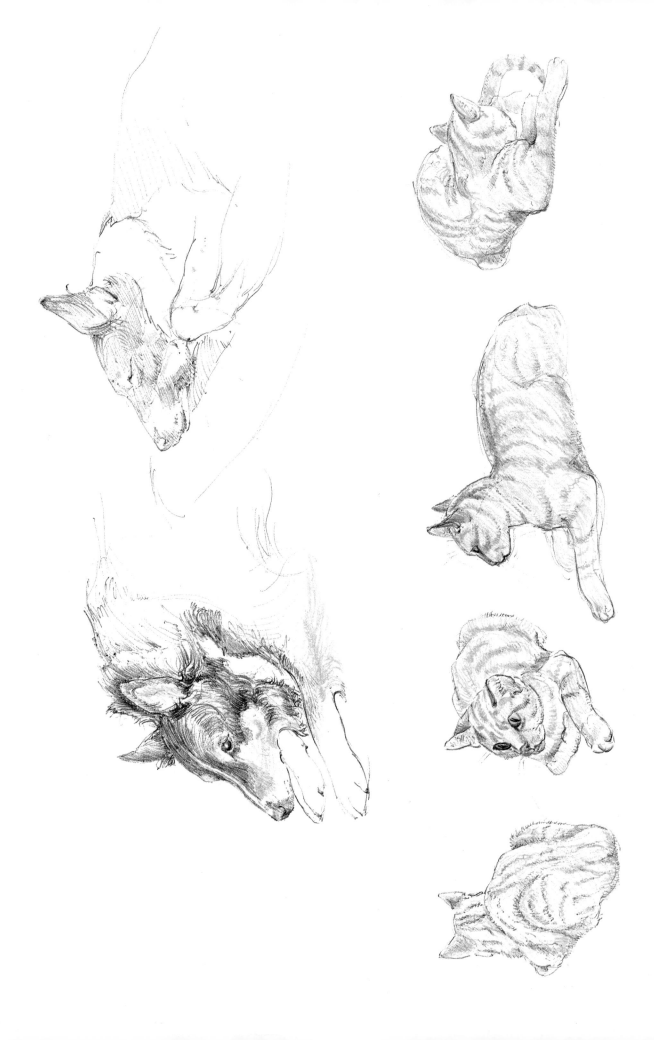

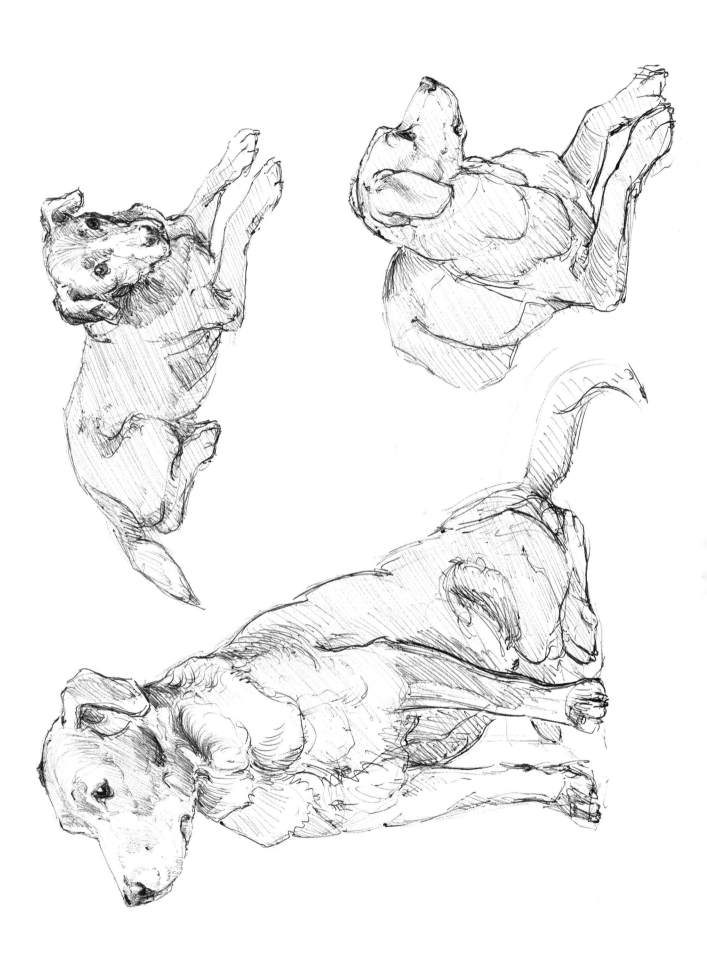

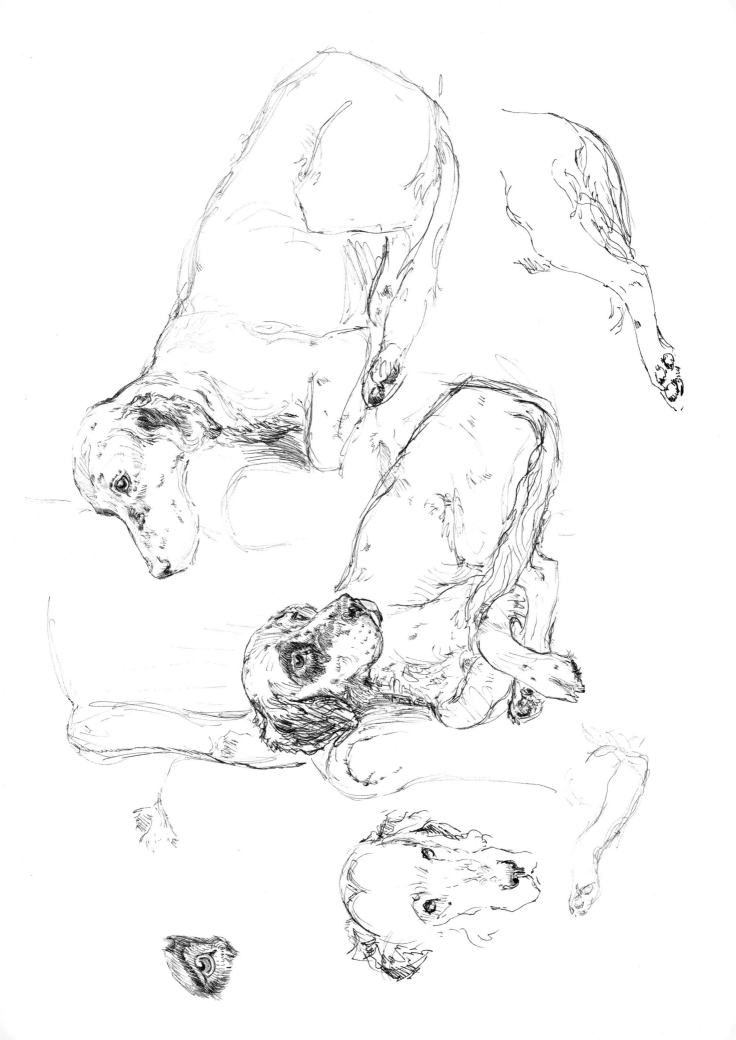

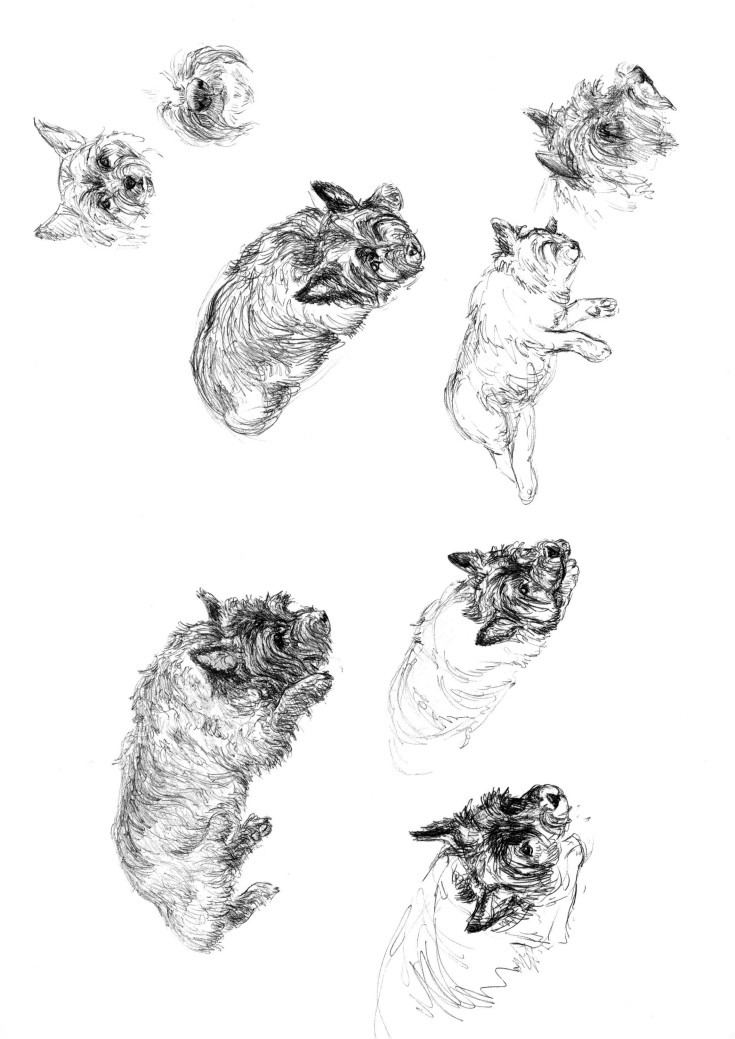

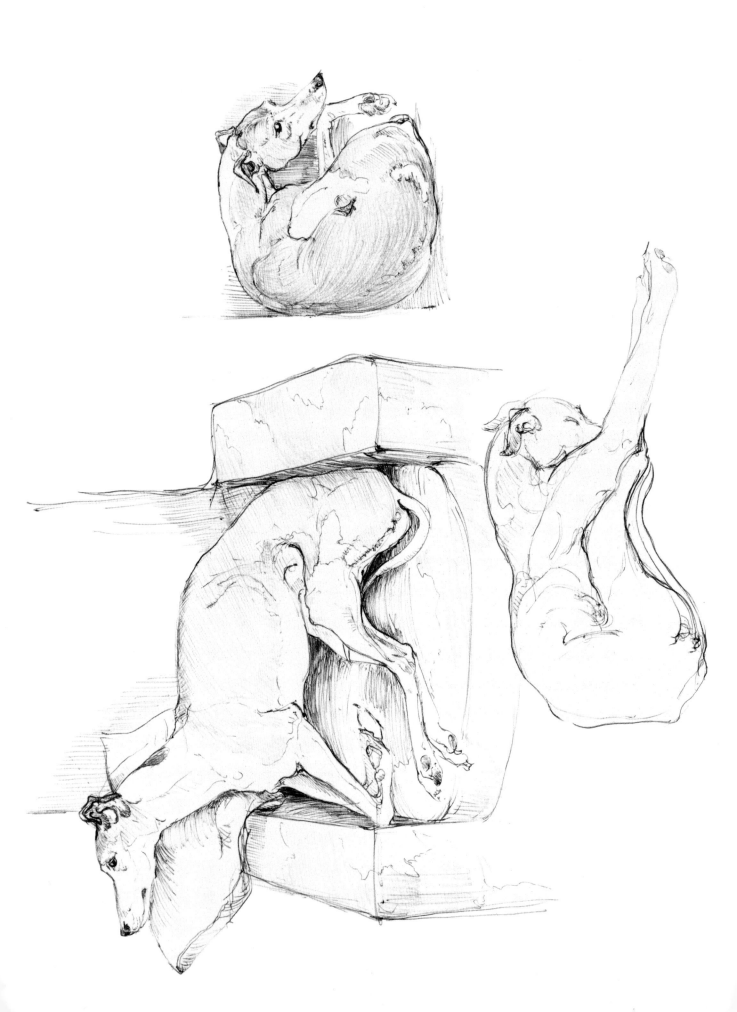

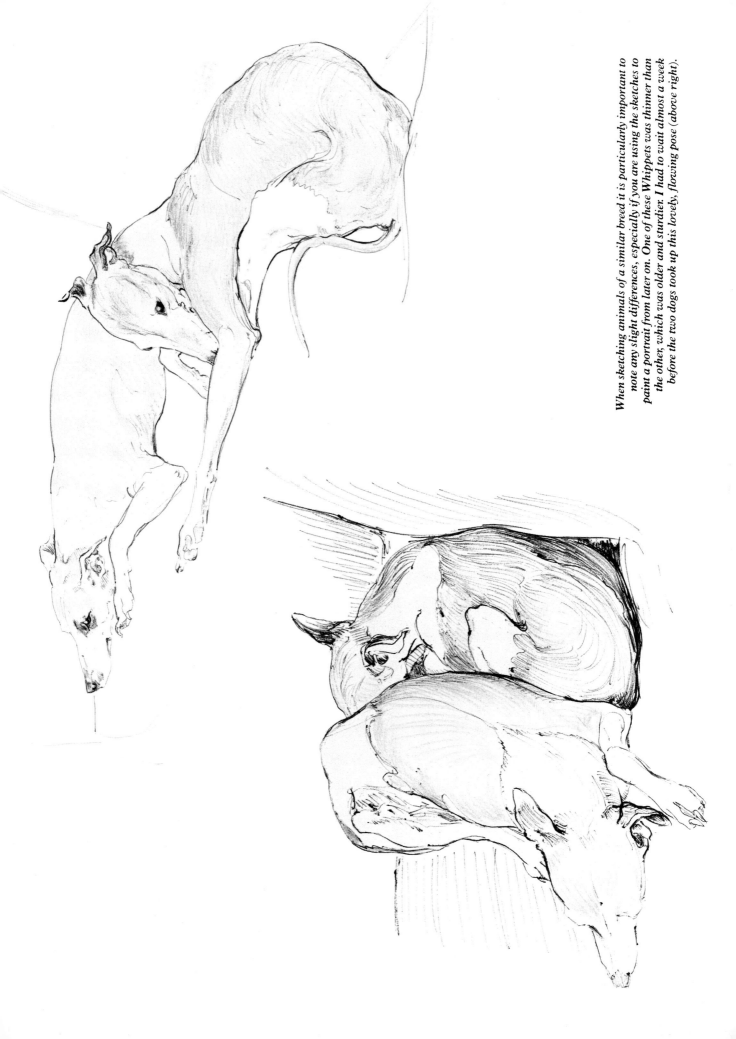

When sketching animals of a similar breed it is particularly important to note any slight differences, especially if you are using the sketches to paint a portrait from later on. One of these Whippets was thinner than the other, which was older and sturdier. I had to wait almost a week before the two dogs took up this lovely, flowing pose (above right).

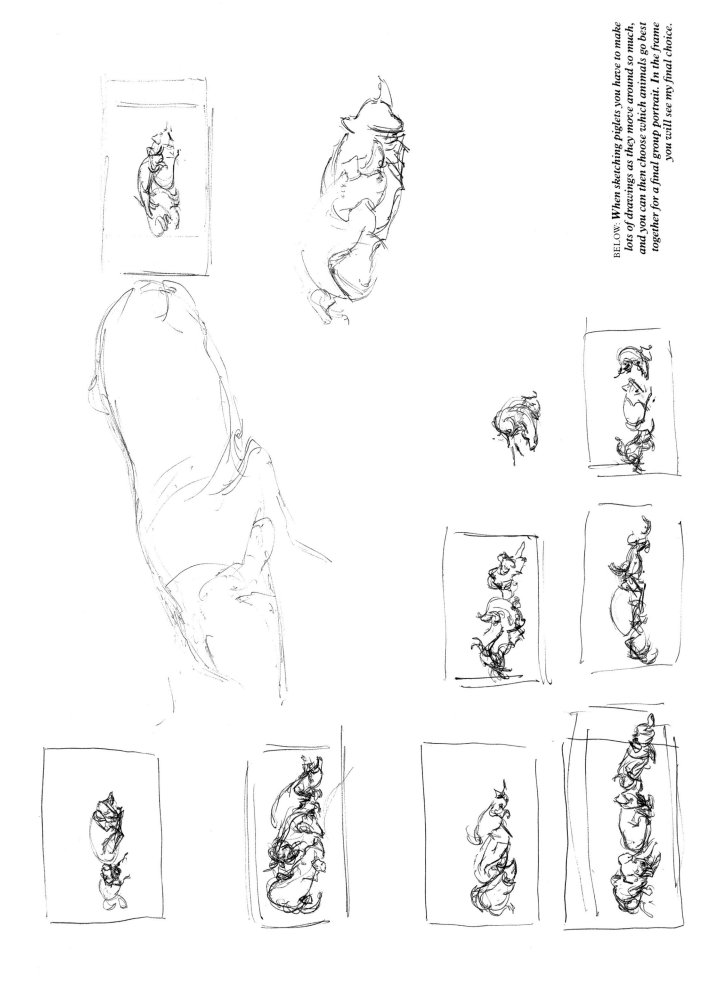

BELOW: *When sketching piglets you have to make lots of drawings as they move around so much, and you can then choose which animals go best together for a final group portrait. In the frame you will see my final choice.*

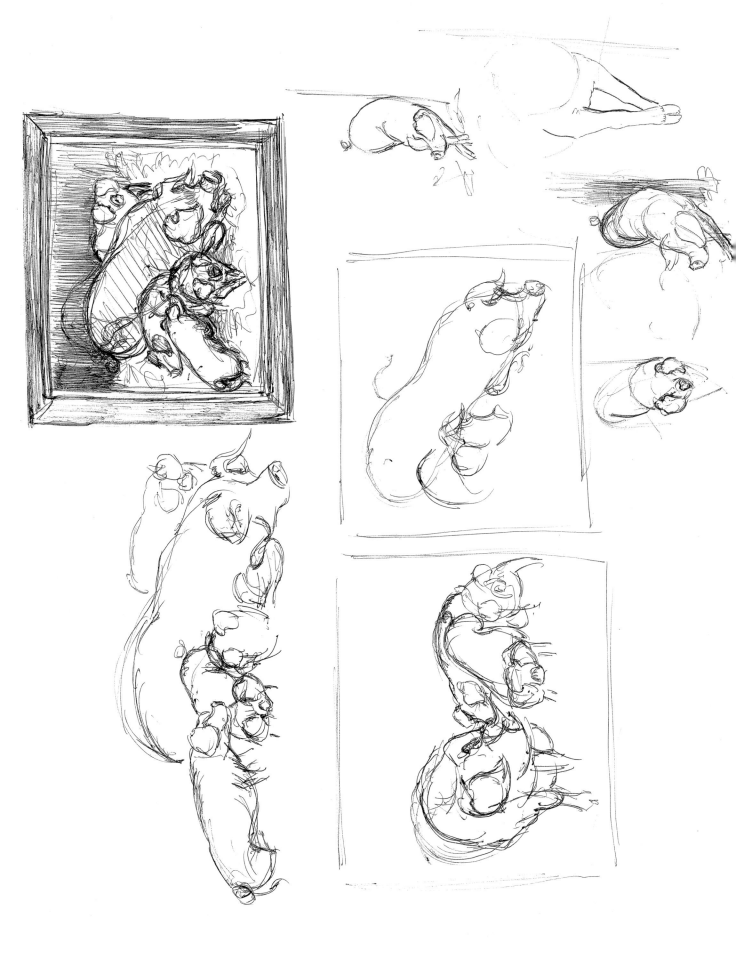

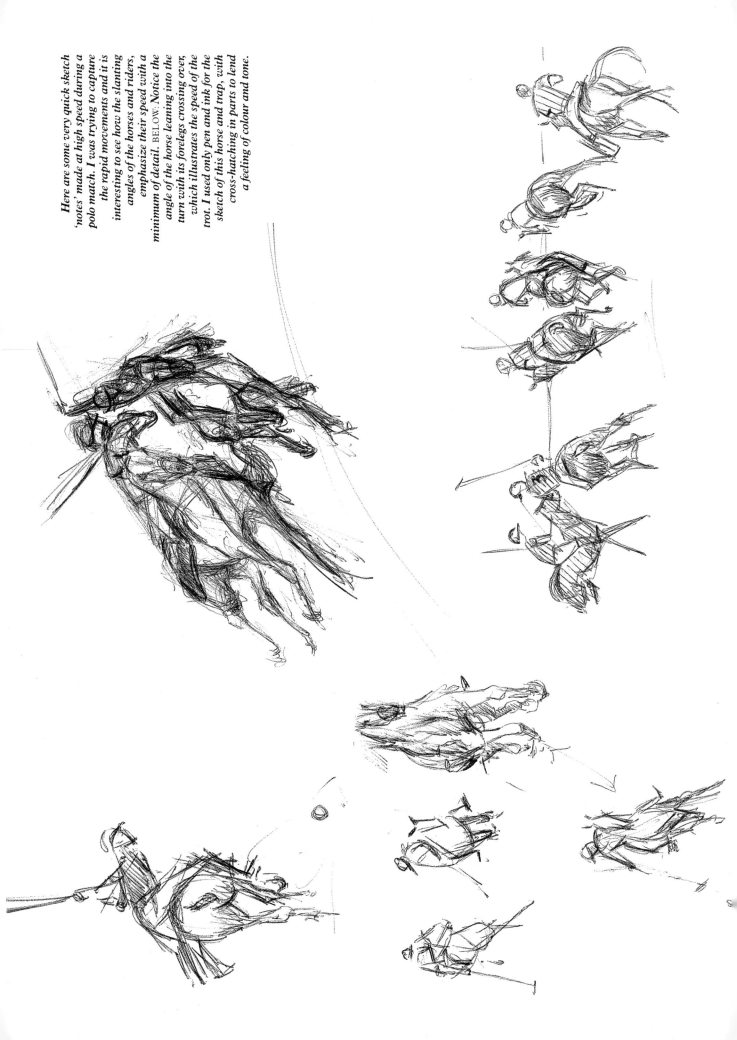

Here are some very quick sketch 'notes' made at high speed during a polo match. I was trying to capture the rapid movements and it is interesting to see how the slanting angles of the horses and riders, emphasize their speed with a minimum of detail. BELOW: Notice the angle of the horse leaning into the turn with its forelegs crossing over, which illustrates the speed of the trot. I used only pen and ink for the sketch of this horse and trap, with cross-hatching in parts to lend a feeling of colour and tone.

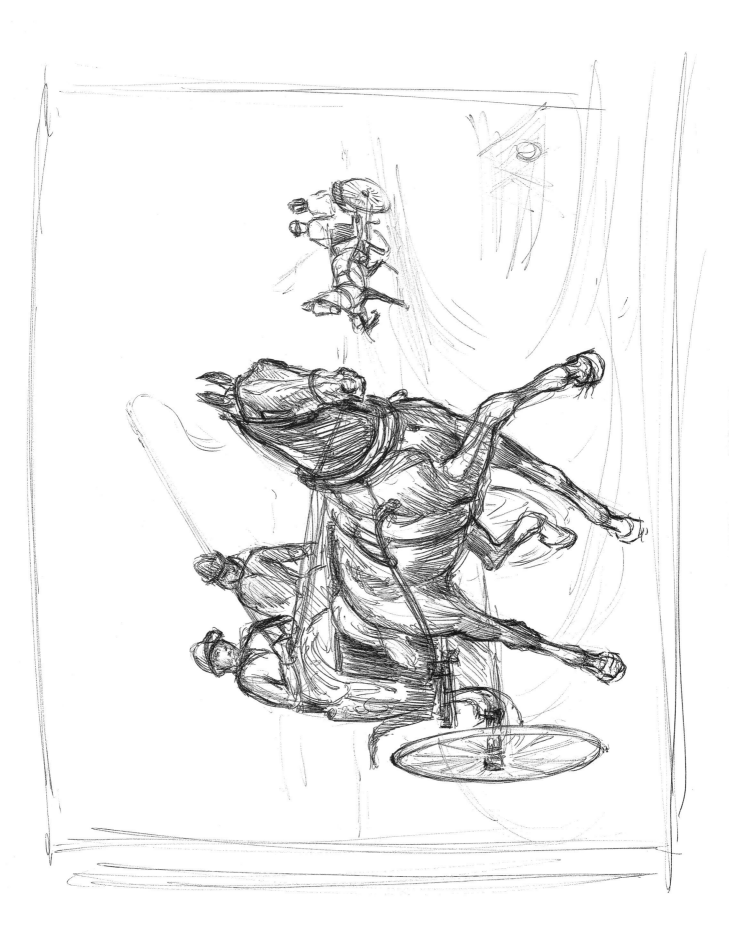

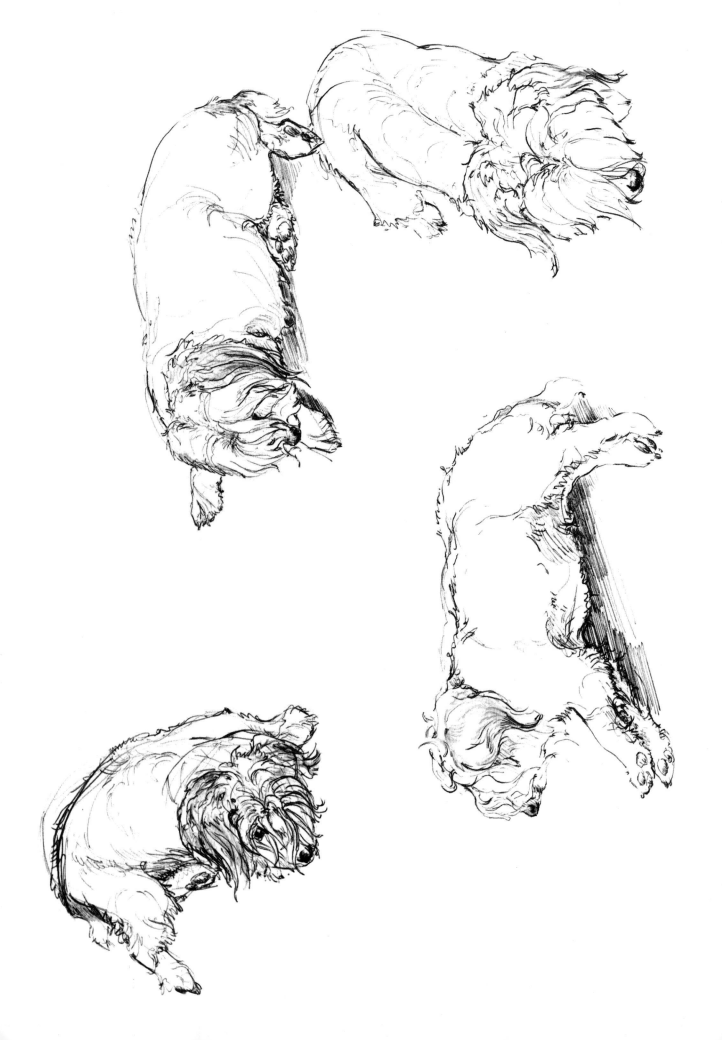

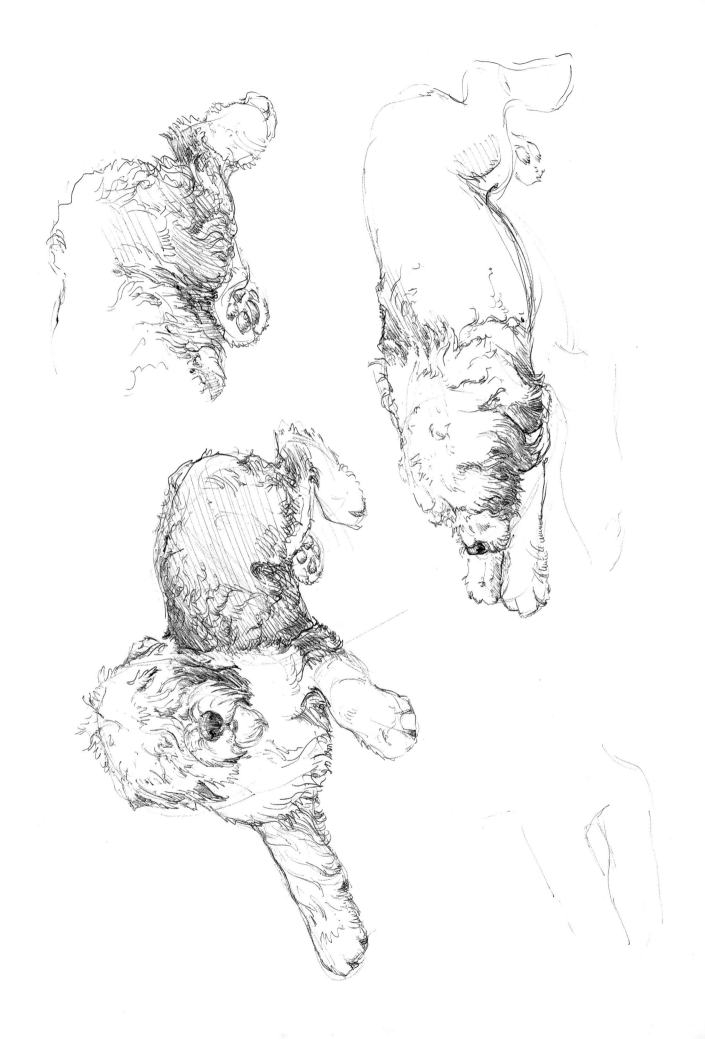

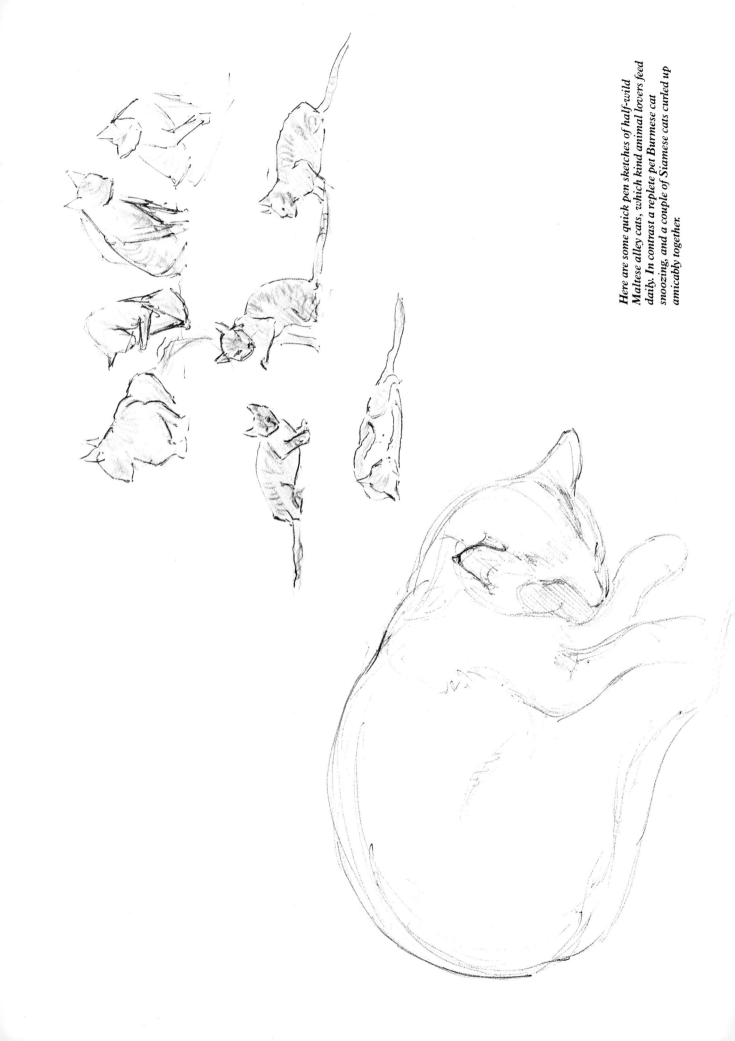

Here are some quick pen sketches of half-wild Maltese alley cats, which kind animal lovers feed daily. In contrast a replete pet Burmese cat snoozing, and a couple of Siamese cats curled up amicably together.

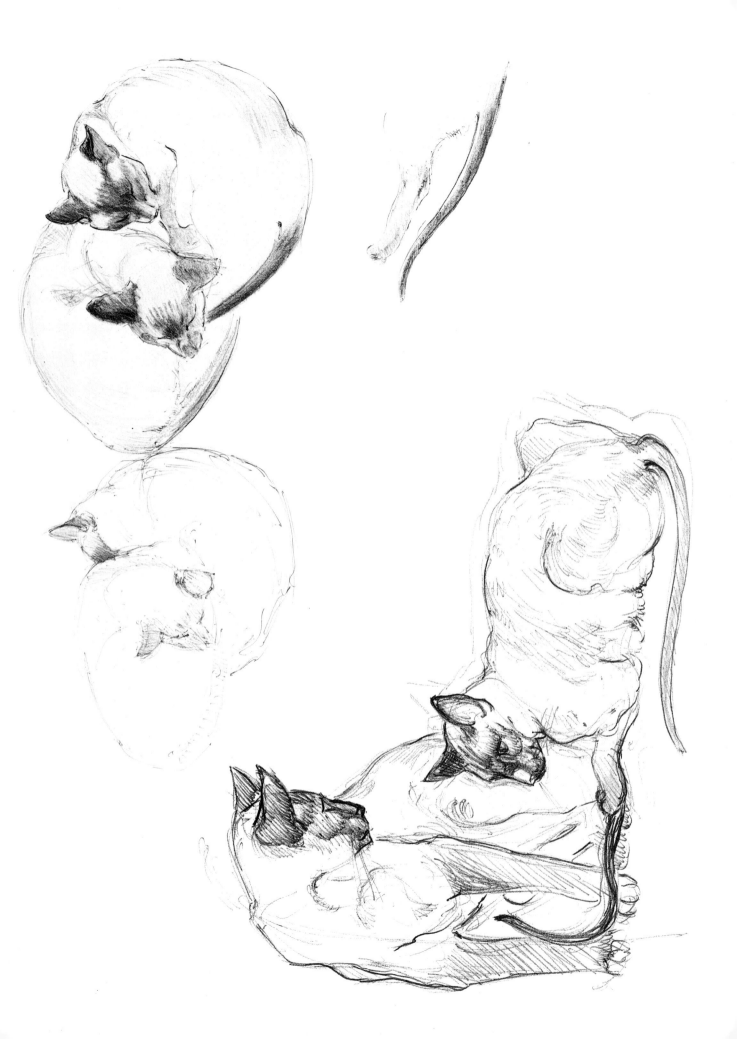

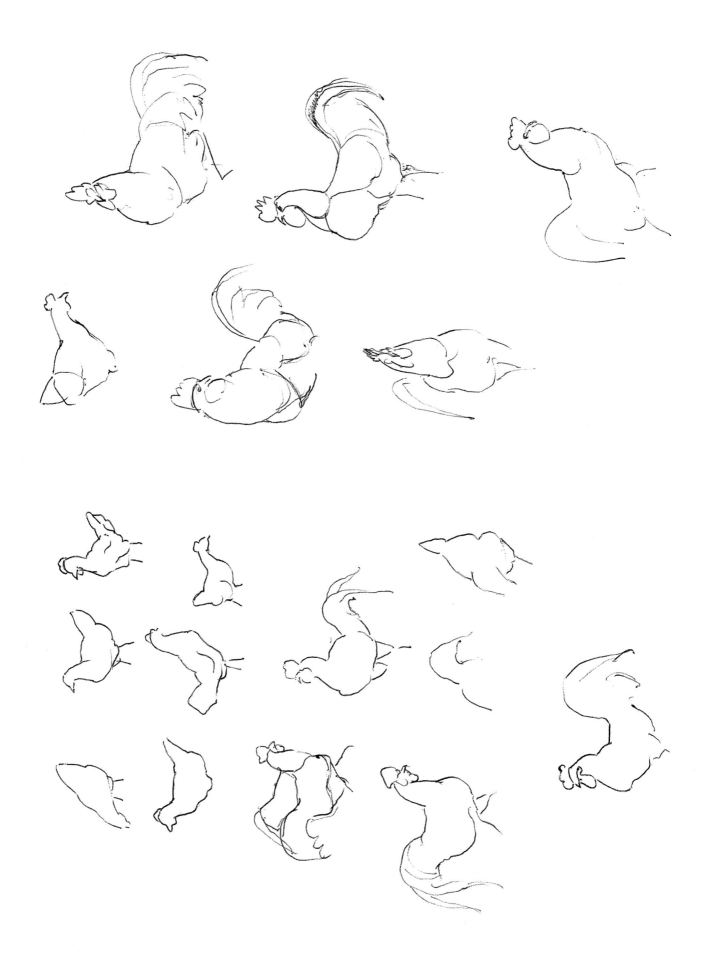

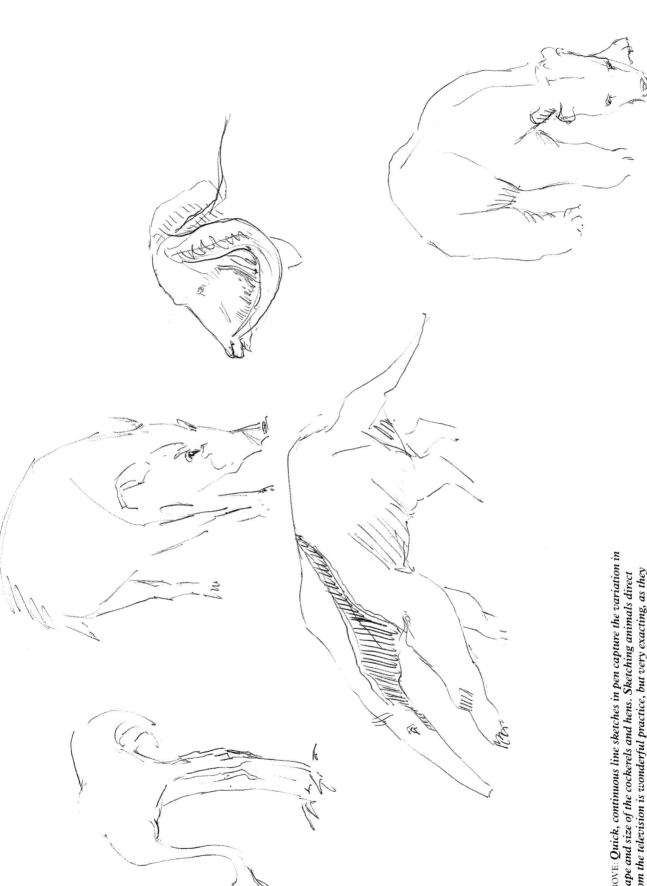

ABOVE: *Quick, continuous line sketches in pen capture the variation in shape and size of the cockerels and hens. Sketching animals direct from the television is wonderful practice, but very exacting, as they only appear momentarily on the screen, like the zoo animals here.*

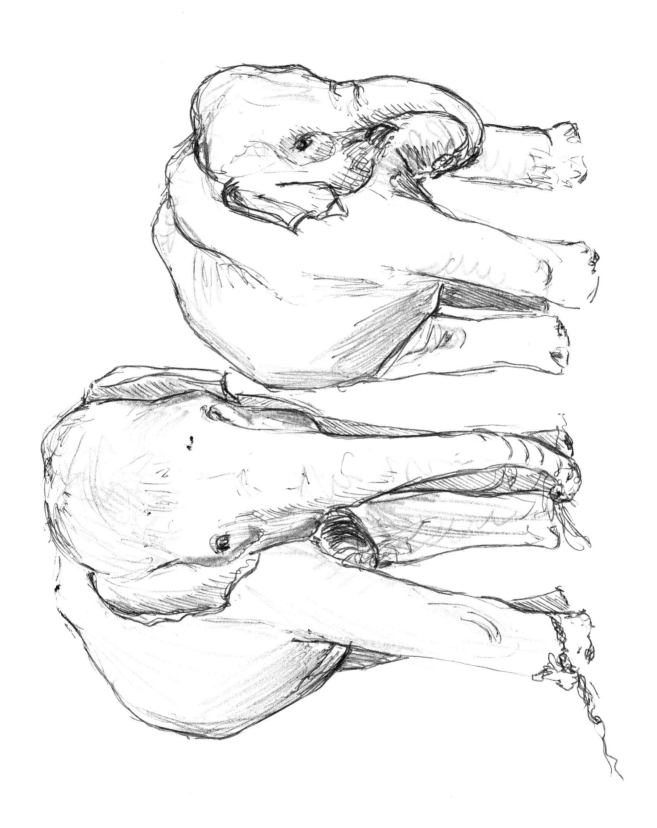